Yeovil's Years

JACK SWEET

AMBERLEY

Front cover: The Borough *c.* 1938.

Every effort has been made to contact the copyright holders.
Please contact the publisher if you are aware of any omissions,
which will be rectified in any future editions.

First published 2010

Amberley Publishing Plc
Cirencester Road, Chalford,
Stroud, Gloucestershire, GL6 8PE

www.amberleybooks.com

Copyright © Jack Sweet, 2010

British Library Cataloguing in Publication Data.
A catalogue record for this book is available from the British Library.

ISBN 978 1 4456 0006 2

Typesetting and Origination by Amberley Publishing.
Printed in Great Britain.

Contents

Introduction 5
Acknowledgements 6

JANUARY 7
New Year 1900 7
The Great Snow of 1881 10
The Crash of the 1B 12
January 1953 14

FEBRUARY 17
February 1880 17
Death in Barcelona 19
What if? and the Tragedy of the Edgar Family 21
February 1952 and the Death of King George VI 24

MARCH 27
March 1899 27
Yeovil in the 1880s 29
Rugby Past 31
March 1932 33

APRIL 37
April 1912 37
Two Fires 39
The Barwick Park Follies 41
April 1935 43

MAY 46
May 1900 46
'Dinah Mite' 48
VE Day 1945 50
May 1932 53

JUNE 56
June 1869 56
Mr Henry Phelps' Last Ride 59
The Late Adolphus Linnett 61
June 1944 63

JULY 66
July 1854 66
The Wild West Comes to Town 68
Holidays at Home Week 1943 70
July 1916 73

AUGUST 76
August 1942 76
VJ day 1945 79
In tDe Courts 1851 81
August 1948 83

SEPTEMBER 86
September 1880 86
Exeter City Reserves v. Yeovil September 1908 88
Modern Witchcraft 90
September 1918 92

OCTOBER 95
October 1870 95
A Tragedy on the River Yeo 97
The Bombing of Yeovil October 1940 99
October 1952 102

NOVEMBER 105
November 1861 105
From the Files 107
Mayor Making 110
November 1945 113

DECEMBER 116
December 1889 116
Christmas in the Shops – 1898 118
Christmas 1902 121
Parties and Plays 123

New Year 1950 126
End Piece 128

Introduction –
In the Beginning

In the autumn of 1998, the now retired Editor of the *Western Gazette*, Mr Martin Heal, invited me to contribute a weekly article with a local historical context, in the newly launched *Yeovil Times*. For the next seven years until the autumn of 2005, my articles appeared weekly in the Times Past column, and which I calculate numbered some 360 pieces; in October 2005, my articles transferred to the *Western Gazette*.

This book contains some of the articles I wrote during those seven years from 1998 to 2005 grouped into the twelve months of the year – *Yeovil's Years*.

Jack W. Sweet
Yeovil
2010

Acknowledgements

I would like to say thank you to Tim Dixon, the former Editor of the *Western Gazette* for allowing me to reproduce the articles from the *Yeovil Times*, and the South Somerset District Council's Heritage Team for permission to use the photographs relating to 'The Great Snow of 1881', 'The Crash of 1B' and 'VE Day 1945'.

The forbearance of my dear wife Margaret during the twelve years I contributed to the *Yeovil Times* and the *Western Gazette* has been magnificent and cannot pass with my many, many thanks.

January

NEW YEAR 1900

There was little rejoicing in Yeovil, or indeed elsewhere, as the nineteenth century gave way to the twentieth on 31 December 1899. Perhaps most people thought 1900 would be very similar to 1899, so why make a fuss about the new century, and there was a nasty war going badly down in South Africa. In fact, the columns of the local newspapers made little reference to the new century and life went on very much as usual in Yeovil as 1899 passed quietly into 1900.

It was business as usual during the first days of the new century in the Yeovil Magistrates Court. William Smith, described as a tramp, was charged with being drunk but was discharged by the Magistrates on promising to leave town immediately. Another tramp, Thomas Cox, on being released from the town lock-up after serving seven days for begging, was re-arrested for a similar offence in Middle Street – this time he got fourteen days inside (at least he had food and a bed during that time). Florence Gill was fined five shillings and James Hillier two shillings and six pence for failing to send their children to school. For being drunk and disorderly in Kingston, George Martin was fined eight shillings or in default, seven days in the lock-up. The Magistrates granted Mr Pitcher, of the Mermaid Hotel, an hour's extension for the *Western Gazette* supper on 13 January. The case of a former Middle Street jeweller came before the local Bankruptcy Court. Owing to a misunderstanding, the debtor failed to attend and the Official Receiver's application for a month's adjournment was granted. The one time jeweller had assets of £46 16s 3d and a deficiency of £637 5s 3d.

A memorial service for the late Alderman Tompkins, a former Mayor of Yeovil, was held in the Princes Street Congregational Chapel, on Sunday, New Year's Eve and was attended by the Mayor and Corporation who had walked from the Municipal Offices to the chapel, led by the Mace Bearer carrying the black draped town mace. In his sermon, the Pastor referred to the loss to the church and the town from the death of Alderman Tompkins who had been honoured, trusted and loved by all classes of people. The Pastor concluded by saying that: 'The example of a Sunday School boy

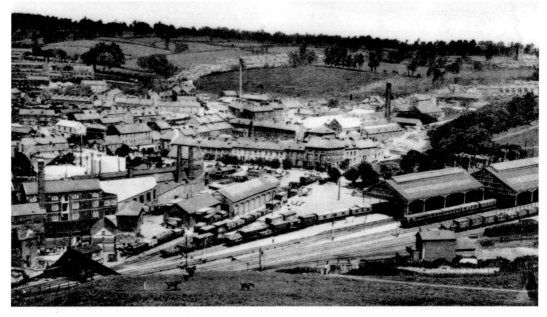

Looking over Yeovil from Summerhouse Hill.

working his way up to have the highest honour the town could confer upon him was a splendid example to all.'

On 5 January, the *Western Gazette* reported the sudden death at his home on 29 December of architect and surveyor, Mr Edward Vining, the eldest son of the late Borough Surveyor, Mr Richard Vining. The *Gazette* wrote that Edward Vining 'had lived in Yeovil all his life carrying on a lucrative practice. He was 47 years of age and was married about 18 months ago and leaves a widow and a young child ... The deceased was of a somewhat retiring disposition but was esteemed by a wide circle of friends.'

The Revd J. Phelips, Vicar of Yeovil, had conferred upon him by the Bishop, a Prebendal stall in Wells Cathedral. The collection at St John's church on the last Sunday of 1899 was £5 16s 7d and Holy Trinity's collection was £2 16s 7d.

It was reported that nine new patients had been admitted to the hospital in December, eleven were discharged, there had been one death and thirty-six outpatients had been treated. Gifts to the hospital during the month, which the 'Matron desired to thank all who contributed,' included magazines, scrapbooks, three bed jackets, medicine bottles and old linen, a bottle of wine, three brace of pheasants, rabbits, apples, pears, oranges, grapes, cakes and a plum pudding.

The Matron and 'inmates' of the Corporation Almshouse desired through the local column of the *Western Gazette* 'to express their thanks for a tea given by Miss Annie Oakley, Middle Street. The treat was keenly enjoyed and much appreciated.'

Yeovil Fanciers' Association held their last show in 1899 of poultry, pigeons, cage birds and rabbits at the Full Moon Hotel.

On 3 and 4 January 'The Joking Girl', a musical comedy, was produced at the Assembly Rooms in Princes Street, by Mr R. Pointer's company. Notice was given in the *Western Gazette* that Mr Parson's dancing classes would recommence on 13 January.

A special sermon on the South African War was preached on the last Sunday of 1899 at the Newtown Primitive Methodist Chapel, and the Salvation Army held a special day of intercession for the troops. The *Gazette* reported that: 'In view of the crisis through which the country is now passing, a meeting for confession of sin and prayer that God would continue to graciously regard our Empire and give us the Victory, was held at the Baptist Chapel on Thursday evening. There was a large attendance. The meeting was under the auspices of the Free Churches.'

The local Company of Volunteers' orders for the week commencing 1 January 1900 announced Squad Drill for recruits on Tuesday, Wednesday, Thursday and Friday at 7 p.m., and *Pulmans Weekly News* reported that: 'The following members of the local Company of Volunteers have volunteered for the front – Lieutenant Urwick and Privates Dover, England, Roberts, B. Vickery and Warr.' *Pulmans* also reported that: 'Mr W. Seymour of Hillside, Sherborne Road, has received from his son who is serving with the Somerset Regiment in Natal a letter, in which he says that the Boers are getting sick of the war and are in a state of starvation. It has been reported that the writer of the letter has been wounded but as the Somersets have not yet been in action since their arrival in South Africa, the report is probably unfounded.' (The war would last until May 1902.)

Finally, the *Western Gazette* reported briefly on the scenes in London on that last New Year's Eve of the nineteenth century:

'A rumour was abroad on Sunday that the police intended to prevent any crowd from assembling near to St. Paul's on New Year's Eve and celebrating the advent of the New Year in customary fashion. The rumour was false. The crowds on Ludgate Hill and around St. Paul's were very orderly and the police had no work to do. People began to assemble soon after 11 o'clock, and little processions bearing stone jars marched down Fleet Street, and took up a position as near to the Cathedral as the previous comers would allow.

'The enthusiasm of the crowd – mostly Scotsmen – was genuine enough, but its modes of expression were limited. There were cheers, and peacocks' feathers, and bags of confetti. But that was all. It was a new kind of confetti, packed in oval shaped bags of gaily-coloured paper, and the bags were attached to short sticks. You hit the man nearest to you with the bag, which burst. Then, if he looked cross, you held out your hand, and brushed the confetti from his shoulders. In 99 cases the person attacked retaliated with more confetti, and the street sellers did a splendid trade. No one knew why people wanted to buy peacocks' feathers, but the supply was large.

'As the clock of St. Paul's struck twelve those people who had waited for an hour near the railings began to cheer, and then the people standing half way down Ludgate Hill remembered what they had come there for, and they cheered too. A few people sang "Auld Lang Syne," and many more "Rule Britannia." The police allowed the traffic to pass, the crowd melted away, and in half an hour's time the place was as deserted as it usually is at half past twelve on a Monday morning.'

THE GREAT SNOW OF 1881

Early January 1881 was cold with some severe frosts, but no worse than most winters. However, on Tuesday the 18th, the temperatures fell rapidly across the country and a blizzard roared out of the north. The storm began early in the morning and by noon snow drifts driven by the bitter wind had blocked many Yeovil streets to a depth of six feet. Pedestrians struggled around the town and wheeled traffic was brought to a standstill.

Staff at the Town and Pen Mill Stations struggled to keep the track and points open and trains were severely delayed or snowed in. The Tuesday 5 p.m. South Western Railway's down train due in Yeovil at 8.30 p.m. finally arrived at 4 o'clock on Wednesday morning, while the 9.10 p.m. up train was twelve hours late. The driver and fireman on one of the Exeter to London trains, which had struggled through to Yeovil Junction in the teeth of the blizzard, were almost unconscious with cold, with the driver claiming to be frost bitten.

The snow eased a little during the Tuesday evening, but a second blizzard roared in around midnight and continued for most of Wednesday. Chaos was complete; Yeovil, along with many other towns and cities across the country, closed down. Traffic on

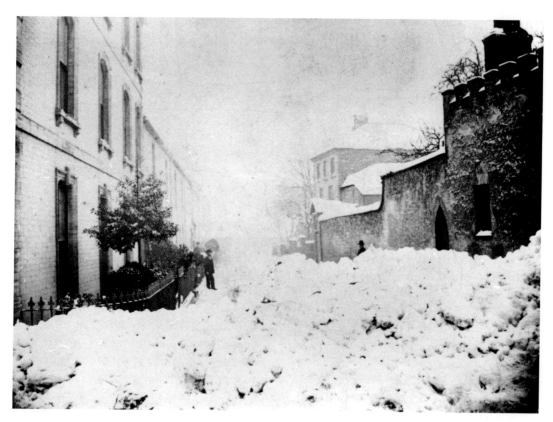

Snowdrifts blocking Peter Street during the Great Snow of 1881.

the South Western Railway stopped completely for much of Wednesday with trains trapped in stations or in deep snowdrifts. The Great Western Railway suffered equally and on Wednesday morning a goods train was snowed in on the down line just north of Pen Mill. After several hours the train was dug out and brought into the station siding; the track was then opened for a limited amount of passenger traffic. However, the lines north and south of the station became blocked by drifts and once again traffic came to a standstill. During Wednesday evening a passenger train was caught in a drift near Pen Mill and the four engines sent to pull it into the station were themselves trapped for some time before they could break free from the snow.

Movement by road was fraught with danger, and few ventured beyond the town limits. A boy went out to get bread in Chard and falling into a drift was unable to get out and froze to death; he was found with the bread by his side. The Yetminster policeman got into difficulties in snow drifts as he tried to get through to Yeovil Junction and was forced back, just managing to get home before the cold could overwhelm him. On Wednesday, a postilian from a Yeovil hotel set out in the blizzard for Bradford Abbas and was not heard of for the rest of the day; it seems, however, that he survived the ordeal.

The blizzards closed the Yeovil shops for the two days and many did not open on the Thursday. The Town Council took on thirty men to clear the drifts and a photograph of Peter Street, taken a few days later, shows how deep the snow had been. By Thursday the railways were passable, but traffic was slow and all trains serving Yeovil were delayed, despite the efforts of hundreds of men engaged in clearing the lines.

It snowed again during Thursday night and although six to eight inches fell, there was little drifting. It was estimated that snow had fallen for about eighty hours over the three days and the freezing weather continued for several more days causing considerable hardship and disruption. Workmen were laid off without wages because of the fearful conditions, but many found paid employment with the Town Council and the Railway Companies in snow clearing. Others earned a few shillings clearing snow from the pavements in front of shops and business as required by the Town byelaws. In Montacute, some fifty men, who had been thrown out of work by the weather, cleared the village streets and the Yeovil road so far as Houndstone. It was reported that they were amply rewarded for their hard work.

The following story from the *Western Gazette* of 28 January 1881 describes the epic journey from Pen Mill to Dorchester of a passenger train which set out on the Wednesday afternoon:

'A train left Pen Mill Station, Yeovil, on Wednesday about 3.30 p.m., with three engines and made its way satisfactorily through a mass of snow and in a biting wind to Evershot. It met with a slight check at Yetminster Station, where the engines made several ineffectual attempts at a start. At last with a mighty push they got through and reached Evershot at 4.30. Here the train had to stay for about three hours as the staff was at Maiden Newton. The telegraph wires were brought into use pretty briskly, and the result was that a plucky fellow started with the staff, notwithstanding that the storm raged furiously. He was exactly two hours coming the four or five miles. He could hardly face the storm, which was so violent, that it almost took away his

breath. The snow too, was in places four or five feet deep, but still he stuck to his task and came in a fearful state of perspiration. The train was then set in motion, and the engines cut through the deep snow in brilliant style. When they got to Maiden Newton, Mr Gray, the Station Master, had some unpleasant intelligence for the passengers, part of a goods train on the way to Dorchester having got off the line about a mile from Grimstone Station. The engines started with a good number of men with shovels, and with aid of some of the passengers, who volunteered their service, and after long toil, the two empty trucks were got on the road and three full ones off. It was almost given up as a bad job, and the engines returned to Maiden Newton for water. The news they brought did not make the waiting passengers light hearted. After some time, another start was made for the scene of the broken down train and the "goods" was at last safely brought back to Maiden Newton. Then the three engines were coupled together and were started to cut their way through to Dorchester. They nearly accomplished their task, but just outside Poundbury Tunnel they ran into a fearful drift and the fire of the front engine was put out. Luckily they were not far from the signal box, and the fireman took the staff on and told his tale. Mr Yeo at once sent to Weymouth and two powerful goods engines came to the rescue, pulled the three engines out, and took them into the station. Then the two started for Maiden Newton about seven o'clock and the train was brought into Dorchester shortly before breakfast time – eight o'clock. There was a good number of passengers and amongst them was the High Sheriff of Dorset (Mr W. R. Bankes).'

I doubt if the passengers and the High Sheriff forgot their journey in a hurry – it could not have been a pleasant experience waiting through a long snowy night in cold railway carriages, or clustered around a fire in a bare waiting room at Maiden Newton Station.

THE CRASH OF THE 1B

For some time, Councillor Harry Seymour had been concerned about the difficult conditions at the Hendford/Horsey Lane road junction. Visibility was poor, Horsey Lane was narrow with no pavements, and on several occasions in 1952, Councillor Seymour had raised the problem with the Yeovil Borough Council. However, as Hendford was part of the A30 Exeter to London trunk road, the Ministry of Transport, and not the Borough Council, was responsible for improvements etc., and the Council had been told that because there was no bad accident record at this road junction it was not on the Ministry's list of urgent schemes. Nevertheless, the Borough Council was concerned, especially as the narrow Horsey Lane was used by local bus routes to Higher Odcombe and Larkhill Estate and commercial traffic going to Hendford Goods Yard and Westlands. At the Hendford end of Horsey Lane there was a low stone wall on the northern side and on the southern, the Hendford Brook ran through a fenced off cutting.

At lunch-time on 8 January 1953, railway worker Mr Thomas Singleton was standing in a lorry in the Hendford Goods Yard and saw the Southern National double-decker

The 1B double-decker bus lying against the Hendford Goods Yard wall.

bus 1B service to Larkhill Estate turn the corner from Hendford into Horsey Lane. To his alarm, he watched the bus topple over onto its left side and heard a crash as the vehicle ploughed through the wooden fence above the stream and came to rest at an angle of about 45 per cent against the Goods Yard wall. The sound of the crash brought nearby office workers and railway men to the scene, ladders were obtained and the top deck passengers were rescued one at a time through the emergency exit because the angle prevented them from safely descending the stairs to the main entrance. Passengers on the lower deck were helped out through the main entrance and up the sides of the cutting.

Sitting in a rear seat on the top deck was Councillor Harry Seymour, whose fears of an accident had now come painfully true, and accompanying him was Mr R. G. Kemble, Sports Editor of the *Western Gazette*, who recalled that: 'There was a crash as the wooden palings splintered like matchwood. It seemed for a moment as if the bus would hang suspended, but as the passengers were thrown together against the near side, the vehicle lurched and crashed against the Goods Yard wall. Frightened children began to cry, but there was no panic.'

Off-duty bus driver Mr Ivor Gray was travelling home to Marlclose and was thrown out through the main entrance into the stream, but quickly recovered and clambered back to help the passengers. He opened the emergency window exit at the back of the top deck and with the help of Mr Kemble, who had broken his wrist, helped passengers through the window from which they were lowered to the ground by rescuers. Local residents turned out with cups of tea for the shocked and bruised passengers, who were

either taken to hospital for treatment or home for rest after the ordeal; some, however, continued their journey on the relief bus.

In addition to Mr Kemble's broken wrist, several passenger were injured – Mr Frederick Sansome suffered cuts to his face and shock; Mrs Peggy Riley, a fractured arm; Mrs Elizabeth Moss, shock; Mrs Elizabeth Consitt, bruises to her chest; Mrs Patricia Gliddon, severe bruising, and four-year-old Lindsay Gliddon, head injuries. Others suffered minor bruises and shock.

The driver, Mr James Bailey, was taken home suffering from shock but his conductor, Mr Alfred Simpson, was unhurt.

Mr D. F. Collihole, the Southern National Depot Manager, praised all those who helped with the rescue work and said – 'We are very appreciative of the prompt and, may I say, expert assistance given by the railway staff and employees of Messrs Burt & Son Ltd, and Messrs Bradford & Sons Ltd.'

A Southern National breakdown crew was called to the scene and worked for almost eleven hours to get the seven-ton bus back onto the road. Initially, two five-ton hand operated cranes and a recovery vehicle were used, but every attempt to raise the bus failed. Finally, a five-ton crane with an extending arm was brought from RNAS Yeovilton and the operation successfully completed by the Naval personnel and Company crew working side by side through the night with the aid of flood lighting and car headlamps.

The accident was raised at the following week's meeting of the Borough Council by Councillor Harry Seymour, who reminded the members of his previous concerns, and the Highways Committee agreed to press the Ministry of Transport for improvements at this road junction. In due course, the A30 was de-trunked in favour of the A303, and the Borough Council carried out some improvements some years later. Today, the Queensway and Lysander Road schemes have completely transformed the area, although the Hendford Brook still runs in its original cutting.

JANUARY 1953

The year 1953 came in quietly in Yeovil; there were the usual New Year's Eve parties, and the pubs were busy. New Year's week saw *Meet Me Tonight* and *Ma and Pa Kettle at the Fair* showing at the Odeon Cinema, and Doris Day would *See You in My Dreams* with *An Angel from Texas* at the Central in Church Street. The Gaumont was showing *The Turning Point* with William Holden and Edmund O'Brian and Charlton Heston was starring in *The Savage*. At the Princes Theatre in Princes Street, the Roc Players presented *Treasure Island* for two weeks.

Coach operators Barlow Phillips' excursions included *Jack and the Beanstalk with Old Mother Hubbard* at Bristol, *Dick Whittington* at Bath, and *Aladdin on Ice* at Bournemouth.

New Year parties for 1953 were bringing good cheer to many of the town's youngsters. Sergeant Bennet, in the guise of Father Christmas complete with his sack of presents, arrived on a decorated tricycle at the Yeovil Police Division's children's

A power cut shut down the X-ray equipment in Yeovil Hospital on 3 January.

party on New Year's Eve. The distribution of gifts was followed by tea, lemonade and ice cream, with Johnnie Doel of Queen Camel and R. J. Staddon's Punch and Judy show providing the entertainment. The Normalair children's party was held in the Odd Fellow's Hall in Earle Street where over 150 youngsters were entertained to tea with a film show, community singing, 'antics by "Big Head Carter" and his performing bear', and a conjuring show by Mr Hazell. Parties for the junior and senior children of St Michael's and All Angels church were held over two days in St Michael's Hall. The older youngsters held their event on Wednesday evening and the juniors the following afternoon when Father Christmas arrived, bearing gifts. When Father Christmas arrived at the Southern Electricity Board's annual children's party, an 'illuminated snowball' came down from the roof of St Michael's Hall and burst to provide a present for each of the 134 children before they enjoyed their tea and a film show; there was also a packet of sweets, two oranges and a sixpenny piece for each of the young party goers.

Staffs of the Odeon and Gaumont cinemas enjoyed their annual Christmas party at Unity Hall in Vicarage Street on New Year's Eve dancing to the Commodore Orchestra with Brian and Keith Saunders providing the entertainment. About 120 members danced to Glyn Morgan's Orchestra at the Westland Sports Club's Annual Olde-Tyme Ball. Members and friends filled the Liberal Hall on 2 January, for the Yeovil Liberal Club's annual Christmas social, and enjoyed the entertainment of Mr R. N. Gulliver's Concert Party and danced to Peter Amey and his Orchestra. The Yeovil Conservatives New Year's party, organised by the Association's joint town wards, was held in the

Drill Hall in Southville on 3 January. Mary Childs presented an exhibition of dancing and soprano, Jeanne Brooks, was the vocal soloist. Miss Christine Whitby directed the evening's square dancing, with John Vincent as MC. The *Western Gazette* reported that during the evening, the Yeovil Member of Parliament, Mr John Peyton, had addressed the two hundred guests, and 'expressed the confident hope that 1953 would see continued progress along what would certainly be the difficult road of establishing prosperity and peace in the world.'

Too much New Year's good cheer found two men up before the Magistrates charged with being drunk and disorderly in the Rendezvous Restaurant in Kingston. Both pleaded guilty and were fined ten shillings each.

Parts of Yeovil were blacked out for an hour on Saturday morning, 3 January, following an explosion in the high voltage junction box at the top of Goldcroft. Homes, factories and shops were affected, and the X-ray equipment at the District Hospital was put out of action for the period of the failure. The junction box was extensively damaged, but power was restored by using supplies from alternative sources.

During 1952, Summerleaze Park School (now Parcroft) recorded the weather for the year, and on 9 January 1953, the *Western Gazette* reported that the recording had shown rainfall to have been evenly spread throughout the twelve months to give a total of 30.40 inches, the five year average being 31.78 inches: 'The wettest month had been November 1952 and the wettest day in Yeovil was 9 September when 1.04 inches of rain had fallen in twenty four hours. There had been a heat wave during June and July with the highest temperature of 87F being recorded on 1 July. Snow fell on eleven days in 1952, three of which were the 28, 29 and 30 March which was very late for this part of the country, and the two days in November was the first time snow had fallen in this month for at least five years.' The lowest temperature was 22F recorded on 26 January and 4 December. The greatest departures from normal in the year's weather were the early cold spells of November and December.

The UK hits of January 1953 were:

Outside of Heaven	Eddie Fisher
Britannia Rag	Winifred Atwell
Make it Soon	Tony Brent
Don't Let the Stars Get in Your Eyes	Perry Como
Now	Al Martino
Glow Worm	Mills Bros

February

FEBRUARY 1880

It's surprising how many of the everyday things we use, and which are so much a part of our twenty-first century lives, have been around for much longer than we think. Take, for example, the cardboard carton – this was first manufactured in 1880; saccharin was discovered in the same year, and so was the safety razor. In 1880, the radio telephone was invented by Charles Sumner Tainter and Alexander Graham Bell, and it was also A. G. Bell who, in that year, invented the 'photophone', which used pulses of light as a means of communication and which, in the 1980s, would become a reality with the development of fibre optics. On the other side of the world in far off Australia (and it was far off in 1880), the outlaw Ned Kelly was hanged but back in Yeovil, the 'criminal' activity was rather less extreme in the first week of February 1880.

On 3 February, George King was brought before the Town Magistrates summonsed by John Tarrant, barber of Silver Street, for assault. John Tarrant told the bench that on 17 January the defendant had come into his shop and demanded some money owed to him. As he did not owe any money, he told King to leave his shop, but the defendant had refused and put his foot on the seat of a cane chair. The barber stated that he had called King 'a vagabond' and pulled the chair away, exclaiming that if he were able he would beat him over the head with it. George King had responded by punching John Tarrant's head with his fist, all of which was witnessed by William Slade who happened to be passing by at the time. The Magistrates dismissed the summons – a case of 'six of one and half a dozen of the other'.

John Rogers was summonsed for ill-treating a donkey. This had been witnessed by Mr Henry B. Batten, who told the bench that on 3 January he had been driving towards Pen Mill and saw the defendant beating the donkey near the *Western Gazette* offices in Sherborne Road. Mr Batten went on to say that Rogers had refused his request to stop and had carried on beating the unfortunate animal. In his defence, John Rogers denied ill-treating his donkey; he stated he was only trying to make it go faster. The plea

Teachers of Trinity Sunday Schools held their annual social in the South Street Schoolroom on 9 February.

was rejected and the defendant was fined two shillings and sixpence plus six shillings costs.

Thomas Templeman and Robert Pardy, described as 'inmates' of the Union Workhouse in Preston Road, were brought before the Magistrates charged with being 'refractory paupers' for refusing to carry out the instructions of Mr Finlay, the Workhouse Master. Robert Pardy was further charged with assaulting Thomas Templeman. The charge of being 'refractory paupers' was dismissed, but the assault was upheld and Robert Pardy was sentenced to fourteen days imprisonment.

Poverty and pauperdom was the lot of many poor Yeovil families in 1880, often brought about by sickness, seasonal unemployment or other unfortunate circumstances beyond the family's control, and local charities would help in many cases. On 6 February, the following letter to the Editor from 'Looker On' was published in the *Western Gazette*:

'I have in my possession the names of several poor families living at Goar Knap who informed me they have been refused coal tickets this winter by Mr. Locke and his agent, because they and their children attend the services and school conducted by the Weslyan Methodists. As a subscriber to the coal fund I demur at such abuse being made of a public charity and trust that such conduct will be frowned upon, alike by Church people and Non-conformist of the town.'

The following week 'A Subscriber' replied:

'Allow me to suggest that the coal tickets should be distributed in the same manner as the tickets for soup. The subscribers send in lists of poor persons they wish to recommend; these are arranged by the committee and an officer is appointed to distribute the tickets. This plan gets rid of all undue influence and works admirably.'

Bearing in mind these two letters to the Editor, the weekly meeting of the Young Mens' Christian Association (the YMCA) discussed the subject of 'Which exerts the greatest moral influence, the Pulpit or the Press?' It was reported that 'an animated discussion' took place at the well attended meeting, Mr S. Aplin championing the press and Mr Ebenezer Hamblen, the pulpit; the majority of the speakers were in favour of the pulpit.

Some sixty teachers of the Trinity Sunday Schools and friends held their annual social in the South Street schoolroom on Monday evening 9 February. Mr Scettrino provided the tea and the decorations were described as neat and effective consisting of banners, evergreens, flowers and flowering plants. As the tea tables were being removed, Mr H. Burt exhibited 'his beautiful set of electrical instruments and his experiences with them were much admired'. Other tables were covered with albums, stereoscopes, collections of shells, 'rare and beautiful work', curious old books etc. There was vocal and instrumental music and 'all who took part in the proceedings appeared to enjoy themselves most thoroughly, if a steady buzz of friendly converse and constant ripple of merry laughter can be taken as evidence of delight'.

A meeting in the Institution Hall in Church Street on 6 February decided to form an orchestral society in Yeovil, a committee was elected and subscriptions set at seven shillings and sixpence for the first quarter. The first practice would be held as soon as the committee could obtain the use of a suitable room.

The General Post Office agreed to place a new post-box in the wall at the corner of Lyde Lane and Sherborne Road, but although it was generally agreed that the site was not the best, the *Western Gazette* acknowledged that 'it would provide a great boon to the inhabitants of the neighbourhood'.

Mr Thomas Holt, the Town Mace Bearer and Town Crier, died on 7 February, after a week's illness, aged seventy-six years. For many years, Mr Holt had been Superintendent of the Town Police prior to its disbandment and the transfer of control to the Somerset County Council in 1858, and Mace Bearer for twenty-five years.

DEATH IN BARCELONA

At about ten o'clock in the morning of Friday 24 February 1893, a man walked into the offices of Bofill Brothers, coal merchants of Barcelona, and drawing a revolver fired two shots at Senor Jose Bofill, killing him instantly. He then fired a third shot which seriously wounded Senor Bofill's brother. Running out into the street, the killer waved his revolver at passers-by who replied by throwing chairs and sticks, until finally he turned the weapon upon himself and squeezed the trigger. The revolver misfired and, after being felled by a heavy chair wielded by a coachman, the man was dragged semi-conscious to the nearest police station. The identity of the killer was quickly established

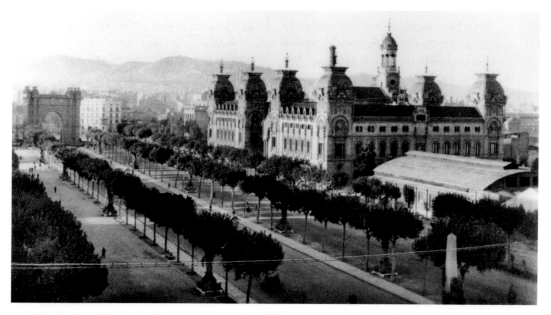

The Palace of Justice at Barcelona where Samuel Willie was taken after the shooting.

as Samuel Willie, a thirty-one-year-old Englishman from Yeovil, and the Barcelona representative of Messrs Watts, Ward & Co., a Cardiff firm of coal merchants and exporters.

On 8 March 1893, the *Western Gazette* reported that the news of the murder in the Spanish city was received in Yeovil 'with the greatest astonishment, as Willie is known to have been, whilst in his native town, of a most affable and agreeable temper. Eleven or twelve years ago he was a pupil teacher at Muller's Orphanage School, and on leaving to occupy a similar position in a school in Spain, which was also connected with Muller's Orphanage, was presented with a dressing case. When in Spain he wrote home to his old pupils several letters about the country. Some years later he became a foreign corresponding clerk to a Cardiff firm of coal dealers, and some months ago he started for this firm a retail branch of the business in Barcelona. There, it is said, he met with some severe opposition, amounting in some instances to absolute trickery. Keen and unpleasant rivalry was excited between him and other coal dealers. The business was a fearful worry to him, and there is little doubt that it quite upset his mind. Quite recently he was in Yeovil, being present at the foundation stone laying in connection with the new Weslyan school-room. He then appeared to his acquaintances to be in his usual health and spirits, but his family believe that his mind was then just on the balance, as he had strange fits of abstraction. He also complained that he had not slept for ten nights previous to his visit home, which was made for the purpose of consulting his employers as to the future of the business. During the week previous to the tragedy his letters and telegrams to Cardiff had been of such an incoherent nature that, suspecting something was very far wrong, his employers sent their manager to

Spain to investigate. Willie had married a Spanish lady, who died some years ago, leaving two children, who are staying in Yeovil with Willie's parents.'

In an interview with Samuel Willie's brother the reporter was told that: 'His business was not simply worrying him, but it seemed to have a complete hold and mastery over him. When he was last in England, he had not had any sleep for a month. The new policy of treating with coal consumers direct instead of through merchants prayed a good deal on his mind.'

While in custody in Barcelona, Samuel Willie tried to take his life on a second occasion by leaping over the banister of a high staircase at police headquarters, but was not seriously hurt in the fall. During interrogation he was said to have been extremely confused constantly shouting – 'I won't sell myself to Senor Bofill! I am not to be bought! Who has sold me?' –but then quietening down on being returned to his cell. When visited by friends, Samuel Willie professed no ill will towards his victims, maintaining that the shooting was the 'result of the temptation of the Devil' and expressing horror at the thought of being considered 'a vulgar criminal.'

Without doubt business problems had played heavily on Samuel Willie's mind, and he may well have been sent over the edge when his Cardiff employers sold out to the Bofill Brothers, completing the deal on the day before the shooting. Samuel Willie was acquitted of the murder on grounds of insanity and admitted to an asylum, but this is not the end of the story.

In November 1894, Samuel Willie had recovered sufficiently for the Spanish authorities to agree to his release and on the last day of the month the *Western Gazette* reported that he arrived home 'at Yeovil, his native place, by the London Express at mid-day on Friday. His face bore a care-worn appearance, but otherwise he appeared to be in fairly good health.'

WHAT IF? AND THE TRAGEDY OF THE EDGAR FAMILY

How often do we ask the question 'What if?' There can be few, if any, historians, professional or amateur, who sooner or later do not ask this question about events in the past and how the present could have been affected by 'What if?' In this article the question 'What if?' is about a double tragedy to a Yeovil family in the 1880s and how this could have affected the history of the town, the development of oil engines, and some important aspects of British aviation.

In 1872, James Bazeley Petter's retail ironmongery business and engineering workshop in the Borough was flourishing, and he bought the Yeovil Foundry at the junction of Huish and Clarence Street (subsequently the site of Douglas Seaton's Garage and now part of Tesco's car park). The manager of the long established brass and iron foundry, Mr Henry F. Edgar, was made a partner, and the firm began trading as Petter and Edgar. The name can still be seen on the bollard in Waterloo Lane. Messrs Petter and Edgar prospered, and the firm's efficient Nautilus fire-grates, invented by James Petter in 1881 and installed by Queen Victoria in Osborne House, were sold nationwide.

Princes Street in the 1890s where Mr Edgar suffered his fatal accident.

Late in the afternoon of Tuesday 2 February 1886, as dusk was falling, Mr Henry F. Edgar and his fifteen-year-old son Henry were taking a short cut back to Yeovil Junction Station from Bradford Abbas along the London and South Western Railway Company's line. Father and son had been to the village on business and were walking side by side along the 'six foot way' between the up and down railway lines to catch the train back to Yeovil Town Station.

When they were about half a mile from the Junction, a goods train, which had just left the station, came puffing towards them in a cloud of steam on the up line to Sherborne. As the goods train passed, for some reason Henry junior stepped back towards the down line just as the Salisbury to Exeter express roared by. The boy received a fearful blow from the side of the engine's cylinder and was killed instantly. As the distraught father raced towards the station, where the alarm had already been raised by the driver of the express, he was met by railway officials coming to his assistance in a shunting engine. The body of young Henry was brought back to the Junction and Dr Aldridge called from Yeovil. Following the doctor's examination of the deceased, the body was conveyed to Yeovil Town Station where it was lodged in the guards' room to await the inquest.

The coroner and his jury assembled in the Mermaid Hotel on 4 February, where Mr Edgar told of the events leading to the death of his son, and explained that the noise

of the goods train had prevented them hearing the approach of the express. Driver Abbott, the driver of the express, told the jury that as his engine passed the goods train and emerged from the cloud of steam, he saw a man in the 'six foot way' but had not seen the second until he glimpsed the deceased's body turning over and over below his cab. The inquest returned a verdict of 'Accidental death' and stated that no railway employee was to blame. Following the verdict, the *Western Gazette* reported that Mr Foster, a Railway Police Inspector – 'Incidentally remarked at this juncture that there was no right of way on the line on which the deceased was walking.'

Fifteen-year-old Henry Edgar was described as: 'A very promising youth having recently left Clifton College where he had gained several educational prizes'.

Three years later, at about three o'clock in the afternoon of New Year's Day 1889, Mr Henry F. Edgar, accompanied by his son Wyn, daughter Florrie and her friend Miss Walters, set out in a hired one horse waggonette, for a pleasant drive in the countryside. The party left Foundry House at the corner of Huish and Clarence Street, and drove down Porter's Lane (now Westminster Street), turned left and proceeded along Princes Street. Outside the recently opened Conservative Club, the waggonette collided with a hand cart loaded with iron gratings being pushed along the street in the same direction by several workmen. The front wheel of the waggonette interlocked with one of the cart's wheels, the gratings rattled, the horse shied at the noise and bolted, dragging the hand cart along only to collide with another small cart some fifty yards further on at the corner of Park Road. The waggonette overturned onto its right side and the four occupants were thrown heavily onto the road. Mr Edgar was knocked unconscious, Wyn received a dislocated right shoulder, and his sister and her friend were badly bruised. Several passers-by rushed to the rescue and the three young people were taken into the nearby house of Mr Denman, but Mr Edgar was not moved as all believed he was dead. Dr Garland was summoned and finding Mr Edgar to be still alive but unconscious, summoned a stretcher, and he was taken back to Foundry House. Despite the continued attention of Doctors Garland, Flower, Aldridge and Colmer, Henry Edgar passed away three days later from a fractured skull with compression of the brain. At the subsequent inquest, the jury returned a verdict of 'Accidental death' and Mr Henry F. Edgar was buried on 7 January 1889, attended by a large number of townspeople and employees of the Yeovil Foundry.

Following the death of Mr Henry Edgar, the Petter and Edgar partnership was dissolved, and with the entry of James Bazeley Petter's talented twin sons, Ernest and Percy, into the business and the appointment of an exceedingly clever all-round engineer and designer, Mr Ben Jacobs, Petters were on their way to becoming the innovative and successful manufacturers of oil engines, and the founding of Westland Aircraft in 1915. The question is therefore, how would Petters and Yeovil have developed if Mr Henry F. Edgar and his clever son had not died so tragically and the partnership of Petter and Edgar had continued? Now there's a 'What if?'

FEBRUARY 1952 AND THE DEATH OF KING GEORGE VI

King George VI died in his sleep at Sandringham in the early hours of Wednesday morning 6 February 1952. The King was fifty-seven years old and had succeeded to the throne on the abdication of his brother, King Edward VIII on 11 December 1936. In accordance with the Constitution, Princes Elizabeth, who was in Kenya on the first stage of a Commonwealth tour, became Queen immediately on the death of her father.

Although the King had been in poor health for some time, and was convalescing from a major operation, his death came as a great shock to the country and in 1952, the Empire. The *Western Gazette* reported that Yeovil: 'Was stunned into unusual quietness at the news of the King's death. Flags were flown at half mast, and the normal gaiety of the shop windows disappeared to a large extent. Grey or black drapes in many cases replaced the usual displays. Factory machines were stopped and workers stood in silence as a mark of respect'.

On Wednesday evening, the bells of St John's church rang half muffled peals, and social functions at RNAS Yeovilton and at Houndstone army camp were quickly cancelled. St Michael's Gay Olde-Tymers (Yeovil) cancelled their weekly dance

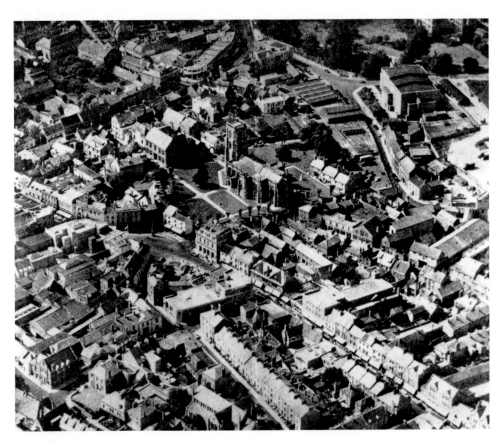

An aerial view of Yeovil town centre in 1952.

on 8 February and the Southern Command Army Cadet Boxing Championships at Houndstone on Saturday were postponed.

The Town Council held a special meeting on Friday morning 8 February, and recorded their profound sorrow at the irreparable loss the nation had sustained by the death of the King, and expressed to Her Majesty, Queen Elizabeth II their steadfast loyalty and sincere wishes for the happiness and prosperity of her reign.

Following the meeting, the Mayor, Alderman Stanley Vincent, led the Aldermen and Councillors, the Town Clerk, the Vicar of Yeovil, Mr John W. W. Peyton MP, Council Officials and representatives of the various public services, from the Municipal Officers in King George Street to the Borough. From a dais erected in front of Messrs Hill, Sawtell's shop, and following a fanfare played by the Bandmaster of the Yeovil Salvation Army Band and four bandsmen, the Mayor read the Proclamation of the Accession to the Throne of Her Majesty Queen Elizabeth II. The Borough and adjoining streets were packed with people, including a large contingent of older pupils from the town's schools and it was estimated that at least 3,000 heard the historic Proclamation. The *Western Gazette* reported that amongst the many amateur photographers recording the scene was someone with a cine camera. The ceremony ended with the Salvation Army Band playing the National Anthem.

The King's funeral was held one week later on Friday 15 February, and the Municipal Offices, together with many shops in the town, closed between 1 p.m. and 3 p.m. during the time of the funeral. Special services were held in the town's churches and chapels during that Friday, and extra seating had to be provided at St John's to accommodate the large congregation. At Holy Trinity church in Peter Street, over 200 people listened to the radio broadcast of the Royal Funeral from Windsor.

More than 1,000 people paid homage to the memory of the late King at a memorial service in St John's church on Sunday 17 February. Led by the civic heads of Yeovil, the main body of worshippers comprised representatives of public organisations, youth groups, Service and ex-Service personnel. Although emergency seating was provided, the aisles and porches of the church were crowded by hundreds of Yeovilians and the service was relayed by loudspeakers to the churchyard where many more had gathered.

On Friday evening 8 February, the residents of some parts of Yeovil, especially in the Pen Mill district, were startled by a muffled explosion, described by one person as 'just like a heavy bomb in the distance.' The cause of the explosion was the crash of a Lincolnshire based twin engine Royal Air Force De Havilland Mosquito into a field at Weston Bampfylde near Sparkford and only a few hundred metres from Mr J. Holland's Mill Cottage. The two man crew bailed out and survived the crash, the pilot landing nearby, but his navigator came down nearly twelve miles away. Fire crews from Castle Cary, Wincanton and Yeovil rushed to the scene and quickly extinguished the burning debris.

On 8 February 1952, the *Western Gazette* reported on the talk given by Major General P. G. S. Gregson Ellis to the Yeovil Round Table. The Major General argued that the only way a third world war could be avoided, was by the North Atlantic Treaty Organisation countries becoming strong and thus being in the position to

negotiate from strength. He pointed out that astronomical though the British defence bill appeared it was not so vast when looked at comparatively. Our defence expenditure in 1939 represented three per cent of the national income, in 1944 it was fifty per cent, and we were now going to spend twelve percent. The Major General believed that 'the three arms of the services should be made strong quickly; the Navy to repel the menace of the 300 submarines which Russia was known to possess; the Army had to be able to counter the vast Russian tank threat and ruthless tactics; the Air Force to defend our island against the menace of the atomic bomb and massed parachute attacks, which should war come, would descend upon us. Once we had the requisite strength, however, the speaker was optimistic that a settlement might be made with Russia; the burden of arms with all its economic effect, was no more to their liking than ours in the long run, and once we could confront them with potential forces equal to theirs, they might be more prepared to come to the conference table. The British in the twentieth century had been tragically reluctant to pay for peace in time of peace, and they had paid a terrible price in blood as a result. Fortunately the nation was awakening to the fact that this mistake must never be made again,' concluded Major General Ellis.

March

MARCH 1899

The church of St Michael and All Angels was consecrated on 12 June 1897, and the first Confirmation Service was held on Thursday morning, 2 March 1899, when the Bishop of the Diocese administered the rite to 74 candidates from the Parishes of St John's, Holy Trinity, St Michael's, Limington, Thorne, Mudford, Barwick and Chard.

By the first week of March 1899, the construction of the new branch of the Capital and Counties Bank was nearing completion on the corner of High Street and Princes Street. The building was designed by Yeovil architect, Mr J. Nicholson Johnson, who had also designed St Michael's church, Messrs F. R. Bartlett & Sons were the main contractors, and the extensive stone carving on the two fronts of new bank was being executed by Exeter sculptors, Harry Hens & Sons. It was anticipated that the bank on the corner would open for business within three months.

The *Western Gazette* announced that a former organist of St John's church, Mr Joseph Smith, had been appointed organist of St Paul's church in San Diego, California, and that the San Diego daily papers had contained: 'Very flattering reports of a sacred concert and organ recital given by him in the church where he conducted a highly successful performance of the oratorio of St Paul'.

The children of the Pen Mill Band of Hope enjoyed music, temperance songs, recitations and dialogues in South Street Primitive Methodist Chapel, with Mr Kiddle presiding over the evening's entertainment.

A few days later, a young butcher, who might have benefited from the advice of a temperance song and given up the bottle, was presented to the Town Magistrates charged with being drunk and disorderly in Middle Street on the previous Sunday evening. The bench was told that despite the efforts of his friends to get him home, the defendant had refused, and had been arrested after causing a disturbance. The young man explained that he had recently returned home following an absence of some years in Newport, Monmouth, and had met several old friends, taking a drink with each one. As this was a first offence the bench fined him five shillings or seven days in default.

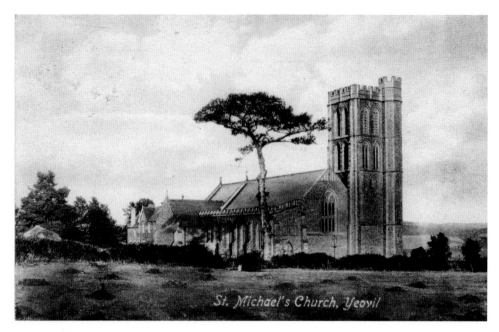

The new Church of Saint Michael and All Angels.

The County Magistrates in session in Yeovil summoned a local man for having no control over the horse he was driving near Mudford. PC Smith stated that he had seen the defendant leaning over the front of the trap and found him asleep. The County bench, being aware of the danger to pedestrians and other road users caused by uncontrolled horses bolting through the streets, fined the defendant the large sum of forty shillings – several weeks' wages.

The danger of an uncontrolled horse was brought home by a report in the *Western Gazette* of Mr J. Derryman's horse with its cart full of milk churns, being suddenly frightened and bolting down Middle Street, through Wyndham Street and into Reckleford, where it was finally brought to a stop. 'Fortunately no one was injured, although the animal narrowly escaped coming into collision with other vehicles and running over children.'

A human runaway was also the subject of a report in the *Western Gazette*. A tramp was brought before the Town Magistrates charged with absconding from the Workhouse in Preston Road – 'Mr F. Wilton (master) stated that the prisoner was admitted on Monday evening as a casual pauper. On Tuesday morning he was set to assist in sawing, but he told the witness he was a bricklayer, and would like to work at his trade. Witness accordingly set him some work to do in the stable, and he commenced working. After he had his diner he absconded over the boundary wall. Witness, who happened to be in an upstair room, saw him going across a field, and went after him with another inmate, and brought him back. – Superintendent Self stated that the prisoner had admitted to him that he had just come out of Dorchester Gaol, and had been seven or eight times previously convicted of felony. He was formerly in the Royal

Artillery and had served over eight years in the Army. – Sentenced to 21 days' hard labour.'

Eight-year-old Bessie Galliott took a tumble in the playground at Pen Mill School, badly fracturing her left arm, and Mr Ernest Whebby was walking through the Borough when he slipped on some orange peel and, falling over, broke the small bones of his left arm, prompting the *Western Gazette* to complain of the 'Orange Peel Nuisance'.

At skittles, a match between Yeovil and West Camel and District, played in the alley of the Half Moon in Silver Street, saw the home team conquer the visitors by forty-two pins, but in the closely contested return match at the Globe, West Camel, the Yeovil team lost by five pins.

'Is the World growing better?' was the question posed in the debate at the Congregational Mutual Improvement Society's meeting on Monday evening 6 March 1899. The vote at the end of the debate was practically a unanimous 'Yes'.

YEOVIL IN THE 1880s

In the columns of the *Western Gazette* in March 1930 an old Yeovilian looked back to the town of his youth in the 1880s and, in so doing, hoped that his article would help the younger generation to more readily appreciate the 'spirit of progressive enterprise that has actuated the Civic Fathers and leading townsmen during the past half century.'

'Ivel', under which name our contributor wrote, stated that in the early 1880s the population of Yeovil was between 8,000 and 9,500 and recalled that:

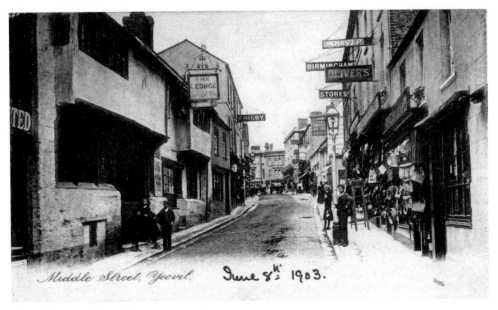

Middle Street and the George Hotel in 1903 – little changed since 1880.

'The houses, generally speaking were small and unpretentious. The existence of large families was frequently the cause of overcrowding; the workers' accommodation being "cribbed" and confined. Sanitary conveniences were sadly lacking. The provision of laid-on water was inadequate; consequently pumps, wells and springs were the principal sources of supply.

'High Street was the principal shopping centre. Memory recalls the name of the leading tradesmen, John and James Curtis, B. S. Penny, W. T. Phillips, Albert Edwards and Hurle Berryman, all drapers and outfitters; grocers were represented by Messrs John Legg, Perrett, Manning, Sawtell, and Worner, the Gun Tea Warehouse; iron mongers by Messrs Hannam and Gillett and Messrs Denner and Stiby; chemists and druggists by Mr Manning and Mr Maggs, Medical Hall (now the site of Burger King). Beneath the Town Hall stalls were utilised for the sale of vegetables, fish and meat. Old Yeovilians will readily recall to mind two well known popular characters that traded there, to wit, Bill Lester, the stentorian voiced fishmonger, and Noah Robins, sen., the grinder. On Friday and Saturday nights itinerant cheap jacks drew large crowds, who were highly amused with the Jack's humorous patter.

'Half a century ago Middle Street did not boast of a decent sized shop window. Those in the occupation of Messrs G. & R. Wadman, drapers and outfitters; Hancock and Cox, jewellers; T. Bunce, boot factor, and J. Fudge, toys and stationery, being practically the only exceptions. The majority of shops were small and unattractive. Several possessed old-fashioned bay windows that overlapped the narrow pavements. The last of these to be demolished were two toyshops tenanted by Mr A. Vincent and Mr J. Lewis. A peculiar feature of many of the premises lay in the fact that ground floor was built below the level of the pavement. On entering the shop one had to step down into the saleroom to gain admittance.

'Half doors were greatly in evidence. The windows of many of the shops were protected at night by board shutters. Gaslight was almost an unknown quantity for illumination; oil lamps, and in many instances the humble tallow candle provided the only gleam of light in the shop window. From the Station Road up to the Triangle stood private dwelling houses. Where the Liberal Club now stands was a dwelling house with a mineral water factory in the rear. This was occupied by a Mr Channing. The interesting feature of this house was the fact that the top of the front entrance door was practically on level with the pavement, several steps leading down to the doorway. The business was subsequently taken over by Mr Trask, sen., about the year 1880.

'Facing the Station Road was the old Railway Inn public house (now the entrance to Central Road). Attached to the inn was a large yard called Foot's yard. This was in great demand for a fair ground, small circus pitch. Cheap Jack's stand, and the itinerant barn-stormer theatre, or, in common parlance, the "Penny Gaff." Two dwellings stood on the spot occupied in later years by the *Western Chronicle* printing office and works (now Wilkinson's site).

'The Triangle derives its name from the fact that 50 years ago there stood on this spot a number of cottages and a corner shop constructed somewhat in the form of a triangle. The lower converging point was used for the purpose of stabling horses. The present position occupied by the present Co-operative Stores (now Porter Black's) was

formerly a baker's and grocer's establishment carried on by Mr H. Connock. An alley led from Middle Street into South Street, or better known in those days as Back Street. Where the Coronation Hotel now stands an old fashioned public house known as the "Blue Ball" stood. Adjoining was a large wheelwright's yard and workshop, carried on by the landlord of the inn, Mr Perry. In my boyhood days during the passing of a severe thunderstorm over the town, a thunderbolt fell, and crashed through the chimney of the inn, causing great consternation and much material damage.

'At the corner of Bond Street to near the George Hotel there existed a row of small shops and cottages. These were thatched with front gardens railed off from the road. On the opposite corner of Bond Street was another thatched house. A Mr Penny, a bootmaker, was tenant. To gain entrance to his little workshop one had to descend several steps below the road level. Frederick Place comprised a builder's yard and workshop belonging to Mr Fred Cox. There was also in Middle Street several courts containing dwelling houses. The last to be abolished was opposite the George Hotel. Memory will also recall an interesting fact concerning the rebuilding of Mr Bowerman's shop, formerly in the occupation of Mr Wm. Cox, jeweller; Mayor of the town during the years 1882-3. Owing to some dispute re the building line, I believe, and to avoid it, day and night shifts of workmen were employed to accelerate the erection of the new building. During the working of the night shifts flares and lamps were constantly burning, the strange sights attracting large crowds to witness the efforts of the workmen to complete the building of the premises. Generally speaking, Middle Street half a century ago was a benighted looking main thoroughfare. Street lamps were few and far between, pavements rough and uneven. Surface water flowing continually down each side of the road caused pedestrians to walk, especially at night, warily and well.'

RUGBY PAST

The Yeovil and District Rugby Club held its annual dinner on 20 March 1931 in the Manor Hotel with the former England Captain, Mr W. W. Wakefield, as guest of honour. In proposing the toast to the Club, the vice-president Major (later Colonel) H. C. C. Batten DSO, stated that he believed the Yeovil Club was one of the oldest in the country, and went on to recall that some fifty years ago certain local 'worthies' were known to chase their opponents around a field called 'Ram Park' (now Sidney Gardens) wearing 'a most wonderful jersey with a skull and crossbones upon it.' Responding to the toast Mr A. E. Bradford recalled his playing days of fifty years before under the captaincy of local solicitor Mr S. R. Baskett when the Yeovil Club played Crewkerne, Chard, Chardstock College, Weymouth College and 'all sorts of teams you moderns have never heard of.' Mr Bradford remembered the occasion when on one winter day the Club, short of two players for the fixture against a 'cramming institution' at Batcombe between Bruton and Frome, arrived at Pen Mill Station, 'and the station master, with whom they were on very good terms, let them have two of his porters who were very good forwards to complete their team. From Bruton station to

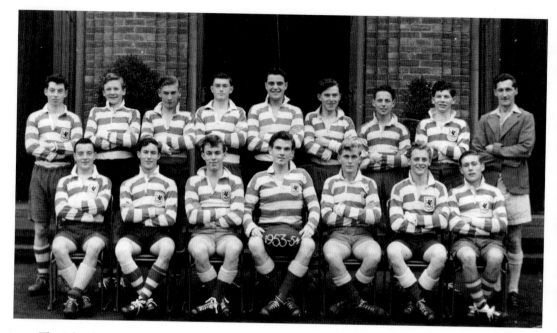

The School 1st XV, twenty-one years after the introduction of Rugby Union at Yeovil School in 1932.

Batcombe was seven miles. It was snowing hard, the horses conveying the team were unequal to the task, and the last two miles uphill they had to walk. They arrived more or less exhausted, and one could imagine the result,' Mr Bradford concluded.

More toasts and speeches followed. Mr J. W. Pearson, the headmaster of Yeovil School (formerly Kingston School) where association football was played, proposed 'The Somerset County RFU', but said that he was not convinced that rugby was the better game for the small boy. It was intended, however, to buy a rugby ball and experiment. However, he had no doubt in his own mind that rugby was the better game despite having been described 'by a person ignorant of the rules as "an obscure form of personal combat".' However, in 1932, rugby replaced association football at Yeovil School, and remained the principal winter term sport until the school's demise in 1974. (Hockey was introduced in 1961.)

The *Western Gazette's* report of the dinner produced the following letter from 'Ivel':

'As an old player of the Yeovil Rugby Club during the years 1889-92, I was greatly interested in reading the report in the *Western Gazette* of the Rugby Club dinner and especially Mr Bradford's reminiscences. As a half back his robust and wily tactics, combined with a forceful personality, was a prime feature of every game he took part in. His partnership with Mr F. Bicknell always provided the crowd with a spectacular treat. What a number of incidents one could record of individual prowess during those far off days. Who of the old brigade will ever forget the magnificent goal and place kicking abilities of Herb Farrant? That goal from just over the halfway line still remains fresh in our memory. What exciting games those matches were in our

experience. Can we ever forget Crewkerne (our local Derby), whether at home or on the Viney Bridge ground?

'I can still recall the names of many of the old stalwarts we met, Watts, Patten, Spearing, Pavord, F. J. Tompsett, R. M. P. Parsons, and the Revd F. Weller, headmaster of the Crewkerne Grammar School. There were also several assistant schoolmasters included in their little lot. What a handful of artful dodgers we met on those occasions! The Taunton fixture was also a popular one, and called into action our best exertions. Prominent players in their team at the time included R. Forrest and H. T. Gamlin, one of the finest English full-backs that ever played in club, county or International Rugby football. My last game against Taunton was played during the skippership of Mr C. Gawler.

'Re the matches played in Ram Park referred to at the dinner, memory recalls the names of players other than those mentioned, Mr Frank Raymond, Mr John Raymond, the late Mr W. T. Maynard and Mr J. S. Aplin. What an interesting memento of those early days a photograph of the be-whiskered team would prove to the present generation. Mr S. R. Baskett's "nanny goat" beard and baggy knicks always proved a great attraction to us youngsters.

'Association football as played to-day was unknown 50 years ago. The game then was a combination of both codes. Strong forward rushes and systematic dribbling formed an important factor in the game.

'Dr Colmer in his football days was reputed to be the most brilliant exponent of the art of dribbling to be found in the home county. That county match at Marlclose; what a quagmire the pitch was! A severe snowstorm occurred a few days before the event was to take place; as a consequence doubts were expressed as to the match coming off. A small army of snow shovellers were set to work to clear the ground, their efforts enabling several thousand spectators to witness an exciting struggle. The players were bespattered with slush and mud; in some respects many were beyond recognition. The popular Somerset giant "Baby" Hancock was a sight for the gods. I heartily endorse the suggestion that the scholars of Kingston School and the elementary schools should be taught the handling code. To foster the spirit in the minds of the younger generation, a nursery of future Rugger players would be assured. Kingston School half a century ago could always be relied upon to put a strong team on the field. I can still visualise them running from the school across to Ram Park in their jerseys of dark blue and white hoops. I remember one occasion when the advertised team did not turn up; the boys played the town club and were beaten but not disgraced. It is up to those who occupy the seat of government to revive the old tradition.'

MARCH 1932

In the first week of March 1932, political party differences were on hold when the Yeovil Liberal Club paid their annual games evening visit to the Yeovil Constitutional Club. The evening included games of billiards, snooker, cribbage and skittles, and refreshments were served the hundred or so members of both clubs and their friends.

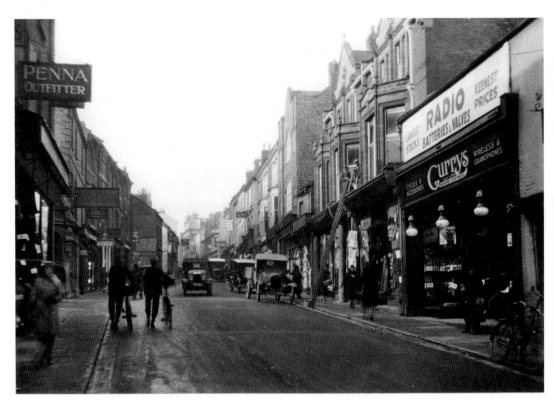

A more congested Middle Street in 1932.

The Constitutional Club won the billiards, despite the 'mild sensation' caused by Mr T. Moon of the Liberal Club beating the Club champion, Mr S. Austin, who went on to win the cribbage and skittles, but lost at snooker.

Other entertainments during the week included a Leap Year Dance organised by the Princes Lawn Tennis Club in the Town Hall with dancing to Stan Payton's New Era Casino Dance Orchestra from Torquay, and the South Street Baptist Junior Fellowship's Leap Year Social in the Newnam Memorial Hall. The Social included games, 'puzzle pictures' of members of the Church, competitions, and a 'Leap Year Sketch' performed by members of the Fellowship entitled 'Aunty's Venture'; refreshments were provided in the 'Leap Year Café'.

The Yeovil and District Co-operative Society held a mannequin parade in the Town Hall and included a new feature – the inclusion of 'male mannequins ... the garments shown gave the audience a selection of the styles for the coming spring and summer, and were of such variety that all tastes were catered for'.

Mr Sweet of South Petherton gave a talk on 'Model Boat Building' to the Model Engineering Society in the Full Moon Hotel – the Society's summer activities planned for 1932 would be confined to model boats and aircraft.

Notice was given in the *Western Gazette* of the meeting of the Yeovil Greyhounds at 3 p.m. on Saturday 12 March on the new track at West Hendford, and if you wanted

to find a winner, Madam Pretoria, Palmist and Clairvoyant, might be worth a visit at 1 Peter Street (consultations daily from 11-3).

An All Electric Wireless set could be bought for £3 10s from the British General Radio Co. (Retail) Ltd, 36 Middle Street, and which would mean No Batteries, No Mess and No Worry; for an extra two shillings a Pix could be fitted to cut out interference.

At the Central Cinema in Church Street, Gloria Swanson was scoring a 'comedy triumph in her latest film *Indiscretion* which although of the lighter vein, has its dramatic moments'; *Daughters of Luxury* and *Love Lies* completed the week's programme. *Annabelle's Affairs*, described as a 'merry farce of a Maid who could get rid of money but not admirers', and *The Black Camel*, a 'thrilling mystery drama in which Charlie Chan solves the puzzle', were showing at the Palace Cinema in the Triangle.

Yeovil and Petters United improved their position at the top of the Southern League by beating Barry 5-0 at Huish; three of the goals came in five minutes, and the *Western Gazette* dismissed Barry's footballing style as 'kick and rush' and their defence as 'not clever'. In the Yeovil and District League, the *Western Gazette* defeated West Chinnock 4-1, and in a friendly the *Gazette's* A-team beat the Old Boys of Yeovil School 5-0 on the Mudford Road Recreation Ground.

Yeovil rugby was not too happy on 5 March when, despite 'a splendid fight', Yeovil and District went down 16-5 at Weston Super Mare and, following 'an all out first half attack', the Anti-Submarine School (Portland) defeated the Westland XV 12-0, for the second time in the 1931/32 season.

Westland Aircraft announced the design of the Westland PV.6 to succeed the famous Wapiti, and which would be developed as the Westland Wallace; 174 of the two-seat general purpose biplanes would be built, and the modified PV.6/Wallace would be used in the 1933 Houston Everest Flying Expedition.

The passengers in Mr C. Burton's 'small touring car' had a lucky escape near Maiden Newton on Sunday 6 March. Mr Burton of Highfield, a Yeovil Town Council Water Inspector, was driving home with Mr Fred Churchill, the Swimming Baths Manager, and his two young daughters, when the car skidded and turned a complete somersault. Thankfully no one was badly hurt, and Mr Burton managed to right his car and drive back to Yeovil Hospital. After treatment for cuts and bruises, Mr Burton and the two girls were allowed home, but the Swimming Baths Manager was detained, suffering from cuts to his hand and discharged a few days later. During his stay in hospital, Mr Churchill might have used one of the twenty-six new radio headsets presented by the Yeovil branch of Toc-H.

Some problems never seem to go away, as Pedestrian's letter to the *Western Gazette* reminds us: 'It would be interesting to know when the Yeovil Corporation proposes to consider the state of the pavements in the town. We have recently been treated to an orgy of street and pavement openings and the condition of the latter in many parts of the town is a disgrace. The footpaths on both sides of Hendford and the west side of Hendford Hill are really deplorable. To my knowledge pedestrians have tripped and fallen heavily due to the uneven and rough state of these paths, and it is high time something was done, but I suppose the Corporation are too busy spending money on

housing to pay attention to such ordinary matters as the proper care of the roads and footpaths. No doubt it is presumption for a mere ratepayer to expect these things to be dealt with, but may we hope that for the credit of the town, something may be done before the meeting of the Bath and West Show, as otherwise the impression created in the minds of thousands of visitors will certainly be unfavourable to the Yeovil Corporation and its streets department.' One man who would not be worrying about the town's pavements or anything else municipal, was Yeovilian, Mr Frank Cooper, who left Brixton in the auxiliary cruiser-yacht, *Vigilant*, on a voyage to the Spanish Main and the Cocos Islands in search of treasure. A crowd of over a hundred waved the nine treasure-seekers goodbye as they set out for Madeira on the first stage of their voyage. Did they find the treasure?

April

APRIL 1912

A national coal strike began at the end of February 1912 as the miners sought a minimum wage, and following the passing of the Coal Miners' Bill by the House of Commons establishing this principle, the National Conference of Miners voted on 6 April to recommend a return to work, and the men went back.

At their first sitting in April 1912, the Town Magistrates received a letter from a local fish hawker pleading guilty to a charge of being drunk and disorderly, stating that he had gone into the country and met some people who had returned home through the coal strike and had some drink; he hoped the bench would deal leniently with him. He was fined twelve shillings.

On the way into Yeovil from Maiden Newton, Mr Staddon was driving his trap down Hendford Hill when, for some unexplained reason, the horse swerved off the road and tried to go through the gate of Mr Bailey's house. However, the horse slipped on the pavement, and both Mr Staddon and his companion, Mr House, were thrown from the trap sustaining severe cuts and bruises. First aid was administered by Mr Leach and then by Dr Colmer. The horse was badly cut and the trap damaged. All recovered.

It was reported that during March 1912, eight patients had been admitted to Yeovil Hospital, eight discharged, one died, and at the beginning of April there were nine in-patients. The Matron acknowledged with thanks gifts from local benefactors of a water pillow and medical appliances, medicine bottles, flowers, illustrated papers and magazines, with donations from patients of two shillings and five shillings and two rabbits.

The Gardeners' Society held their monthly meeting at Hendford Manor Lodge on 2 April with fine shows of narcissus and asparagus. Mr Hobby, gardener to Sir Spencer Ponsonby Fane of Brympton House, read an 'interesting paper entitled "What an Inch of Rain Means" in the course of which he gave some remarkable statistics respecting rainfall of the country'.

Mr Staddon's horse and trap crashed on Hendford Hill.

On 4 April, the 1st Yeovil Troop of B.P. Girl Guides held an entertainment in the Town Hall in aid of troop funds. The *Western Gazette* reported a large attendance including the Mayoress, Mrs Boll, and the Baptist Chapel Girls' Brigade in the charge of Captain Mrs Chaffey and Lieutenant Mrs Shire. The Guides gave 'action songs,' piano solos and duets, recitations, and a presentation entitled 'The Birth of the Union Jack'.

A social evening arranged by 'several energetic members of the congregation of the Catholic Church' was held in the Town Hall on 9 April, and the company enjoyed dancing, songs, piano solos and some excellent refreshments.

The Women's Suffrage Society met in the Boro' Restaurant on 1 April with Miss Brook-Smith in the Chair. Miss Tanner of the National Union Executive and the Revd W. Gummer Butt addressed the meeting on the campaign of votes for women, and the evening ended with an entertainment of recitations and suffrage songs.

A whist drive organised by the Tariff Reform Club was held in the Princes Street Assembly Rooms, followed by dancing to Mr Ring's Blue Band.

D Squadron of the West Somerset Yeomanry held their annual prize shooting competition on 3 April in very good weather conditions at the Lyde Rifle Range. The *Western Gazette* reported that 'considering the men had no previous practice this season, the scores were very satisfactory especially as the shooting was at the new Bisley figure targets.' In the evening the squadron held a dinner and smoking concert in the Mermaid Hotel. During the course of the evening the commanding officer, Major Hamilton, announced that the Mayor of Yeovil, Alderman J. H. Boll, had presented a cup for the squadron to shoot for under 'special conditions.'

On their way home by train from a match in Poole, members and players of the Town Football Club stopped off at Templecombe and adjourned to the Railway Hotel where they presented a silver mounted walking stick and pipe to their President, Mr E. J. Farr: 'As a token of the esteem and appreciation of the kind interest he has taken in the team during the season, and more especially in the away matches.' The *Gazette* reported that Mr Farr rose to acknowledge the gift amid musical honours and the cheers aroused the village. After thanking the players for their pleasing gift to him, he remarked how much pleasure it always gave him to be with 'the boys' and would always remain 'one of them'.

The *Western Gazette* reported on Friday 5 April that the latest news on Captain Scott's Antarctic Expedition had reached London, following the arrival of the expedition's ship in New Zealand on 1 April, and told of 'wonderful escapes and terrible adventures in a great battle between the forces of man and the forces of Nature.' In his last despatch Captain Scott wrote that, 'I am going forward with a party of five men and am sending three back under Lieut Evans with this note. The names and descriptions of the advance party are:- Captain Scott, Royal Navy; Dr Wilson, chief of the scientific staff; Captain Oates, Inniskilling Dragoons (in charge of ponies and mules); Lieut Bowers, Royal Indian Marine (Commissariat officer); Petty Officer Evans, RN (in charge of sledges and equipment). The advance party goes forward with a month's provisions, and the prospect of success seems good, provided that the weather holds and no unforeseen obstacles arise. It has been very difficult to choose the advance party, as everyone is fit and able to go forward. Those who return are naturally much disappointed. Everyone has worked his hardest. So far all arrangements have worked out most satisfactorily. It is more than probable that no further news will be received from us this year, as our return must necessarily be late.'

However, by the time this news had reached the outside world Captain Scott had reached the South Pole on 17 January 1912, only to find that Amundsen had beaten him to it, but his fate was not established until the relief party found the bodies of the explorer and his companions in their snow covered tent on 10 February 1913.

TWO FIRES

Fire is an ever present menace; even today, with all our sophisticated methods of warning and precaution, fire can be disastrous. It was, however, a greater menace in the past when so many buildings in the crowded towns and villages were built from timber and had thatched roofs. A fire could spread with disastrous consequences.

Yeovil suffered two severe fires in the past; the first was in 1450, when 117 houses were destroyed and in July 1640, when Walter Whitcombe's house caught fire and, fanned by a strong wind, the flames destroyed eighty-three houses, scores of barns and outbuildings, and left over 600 people homeless.

Needless to say, anyone caught deliberately starting a fire could expect and receive no mercy – arson was a hanging offence!

On a Saturday night in April 1790, fire broke out at the Greyhound Inn, in what is now South Street, and the cellar and several outhouses were destroyed. On the

Nineteen-year-old Alexander Pearce was imprisoned in Ilchester Gaol awaiting his execution shown here.

following Wednesday, a second fire was discovered in some more outbuildings, but with the help of the Sherborne fire engine, the fire was put out before it could spread to the Inn itself. When a third fire broke out and destroyed the next door smithy, also owned by Thomas Garland, the landlord of the Greyhound, the suspicions of arson were confirmed, and nineteen-year-old Alexander Pearce, a servant at the Inn, was arrested.

Alexander Pearce appeared at the Somerset Assizes in the following August and was found guilty of setting fire to the house and outbuildings of his master. He was sentenced to death and hanged, still protesting his innocence, at Ilchester on 25 August 1790.

On Tuesday 10 March 1863, three people lost their lives in a fearsome fire at the John Bull Inn, in the lower part of Middle Street.

At about three o'clock on the Tuesday morning, Walter Hurdle, a cheese factor, was shaken awake by his wife who shouted 'For God's sake what's that!' and pointed to the bedroom window. Jumping out of bed and pulling up the window blind, Walter Hurdle was horrified to see flames leaping from the John Bull Inn on the other side of the street. Leaning out, he shouted 'Fire! Police! Fire!' for about five minutes, before going down to see if he could help.

The following story emerged at the Inquest into the burning to death of Mrs Gulliver, the wife of the landlord, and her young son and daughter.

The fire, which appeared to have broken out in the kitchen, had taken a firm hold and was burning fiercely before it was discovered by the landlord's eleven-year-old

son Alfred, who woke his father, and then Edward James, the ostler. The ostler slept in the room over the kitchen and flames were already licking around the door when he scrambled out of bed. Climbing out through the window, Edward James dropped into the yard below and, taking a ladder from the empty stable, propped it against the wall under the window. Smoke was pouring from the room and first to leave was the lodger, Richard Warr, who fell off the ladder, but luckily only received slight bruising from his fall; then came John Gulliver, who kept calling back for his son but no one followed.

A neighbour, Robert Hewlett, helped by John Bunn, broke open the doors to the yard of the John Bull, and rushing in met the distraught landlord, who cried that his wife and family were trapped in the front bedroom. Tragically, Richard Hewlett and Constable William Parson's efforts to rescue the family through the bedroom window failed as they were driven back by the flames. An attempt by Richard Hewlett to get into the front bedroom through a second bedroom failed as flames burst through the communicating door and he narrowly escaped death when the roof fell in just after he had climbed out.

The Police and the Volunteer Fire Brigade, with their three engines, were soon on the scene, but all thoughts of saving the landlord's family and his Inn had gone and it was now a question of containing the spread of the flames. Aided by a still night, the Brigade saved the three adjoining cottages and by early morning the fire was out. The badly burnt remains of Mrs Gulliver and her two children were found in the burnt out shell of the Inn.

The cause of the fire which destroyed the John Bull Inn was never established, and the inquest jury returned a verdict of 'death by burning but by what means the fire originated there is no evidence.'

THE BARWICK PARK FOLLIES

The four follies in Barwick Park have intrigued generations of local people because no one really knows why or by whom they were built. Over the years a number of articles have been written about the follies – Jack the Treacle Eater, The Fish Tower, The Rose Tower and The Obelisk (off Dorchester Road) as they are generally called today, but no one has solved the mystery.

Back in April 1930 several letters were written to the Editor of the *Western Gazette* which may throw a little more light on the follies, or perhaps add to the mystery.

On 11 April 1930 the following letter appeared in the *Western Gazette* from Mr E. Jesty (popularly known as 'Kaiser') of 1 Lilburne Road, Eltham, Kent:

'I see by this week's *Western Gazette* that there is some little talk about the towers in Barwick Park and Key Copse. Some 45 years ago my father and I were felling one of the fir trees that had died in the Park near the Rookery Tower (the tower with the ball on top). During the morning Mr Seward (the old expert on pictures and art who lived on Hendford Hill) came over and watched us at work, and helped to get some of the tree down. He asked the age of the old fir tree, and as far as we could tell it was upwards of 100 years. "Then that is the age of those four towers," he said, and he told

Tower in Barwick Park, Yeovil

The Rookery Tower (also called Barwick Steeple and Rose Tower) where Mr Jesty helped his father cut down one of the fir trees.

us that his father knew the man who put the ball on the Rookery Tower, and that the stone ball was six feet across. Mr Seward also said that the man who had the towers built also laid out the Park with those clumps of beautiful firs (Douglas) and silver poplar (Arbelle). The towers were ornaments to the whole scheme, and were named "The Rookery Tower," "Fish Tower," Jack the Treacle Eater," and "Key Steeple." So those towers are about 150 years old. I cannot remember who Mr Seward said was living at Barwick House at the time, but it was before the Newmans and Messiters.'

The 'little talk' about the towers in Barwick Park mentioned by Mr Jesty refers to a comment made in an earlier letter about old Yeovil in which the writer, Noah Robins, said that he was disappointed that no one had come forward with information about the history of the follies.

On 18 April, the *Western Gazette* published the following letter from Mr J. R. Seward of 'Ellors' Preston Road, Yeovil:

'I was interested in the letter from Mr Jesty recording information about the Barwick Towers given to him by my grandfather, the late Mr William Seward. I have pleasure in giving you extracts from a letter I have received from Mr Samuel Seward of Penarth, the only surviving son of William Seward, following my request for assistance in this matter:

'I can add very little information to the points you state re Barwick towers, but can give you the proper names to the erections, as I heard them spoken of and knew them in my early days.

'There were three with a seeming connection, and they lay roughly on a triangle, respecting each other. The only "tower" was about 50 feet high, quite round, of unfaced

stone, some 10 feet in diameter, and of a slight taper towards the top. At the apex, supported by iron bent rods, was a gilded fish.

'A similar tower, pulled down before my time, stood some 200 yards away (to the west) and they went by the name "Lawyers' Towers." As such, I knew the one standing. Its position was a little to the left of a swing and large gate, carving a path down some third of a mile away from Barwick (Messiter's) Pond.

'A mile away, crowning a green, sharp slope, upwards from the Pond stands "Hermes," on his roughly built arch of coarse stone. A little to our left we come to "Barwick Long Lane," sunk between sand banks and a long way down on the right, its base some 12 feet above us inside the field that are immediately at the back of "Hermes – Jack the Treacle Eater." I was never there at the exact time to see him get down when he heard the Barwick House gong sounding to get his molasses, or whatever else they satisfied him with.

'From this spot some mile away (due west) stood the "Barwick Steeple," the scene of the fir tree felling by Messrs Jesty. From a low-standing space, this very long stone steeple of close-dressed stone rose, on a ridge, behind the large house, making the complete three, all within Newman's property bounds.

'My father's favourite, almost daily walk, was in and about this beautiful park, permission being given by the then esteemed owner, a kindly and much respected gentleman, T Messiter Esq., captain of the old Volunteer Company of the 2nd Battalion Somerset Rifles, which I joined in 1867.

'Why these three erections were made, and of three such entirely different styles and appearance, I cannot say. I used to hear, they were built about 1790, or a little latter.

'"Key Steeple," I believe, was not closely connected with the Newman or previously owning people of the Barwick Estate. It certainly is an outlier from it, and quite two miles away (?) but it is almost necessary to find someone more aged by 20 years than myself to throw further light upon its beginning and purpose.'

The Editor added the following comment. 'We have also been informed by a lady, who has lived in Yeovil all her life, that she was told when quite a child that the towers were erected by a member of the Messiter family. His main object was the relief of the great distress which afflicted the district about that time. This seems a widely held belief.'

APRIL 1935

During the first week of April 1935, Whist Drives were very popular – the sports page of the *Western Gazette* carried details of the Yeovil Ladies Whist League and its 18 member teams which included the Duds (joint leaders with Con Club B), Follies, Spooners, Sporters, Rovers, Ramblers and – the Pickups!! On 2 April, a Whist Drive in aid of the Sick Benefit Fund of the Junior Section of the Blue Marines was held in Hendford Manor Lodge, and the Gent's Whist Annual Drive took place the same evening in the Liberal Club with forty-seven tables. The Knock-out Cup was presented to Liberal A, the League Shield to the Ramblers, and the wooden spoon to the Co-operative team.

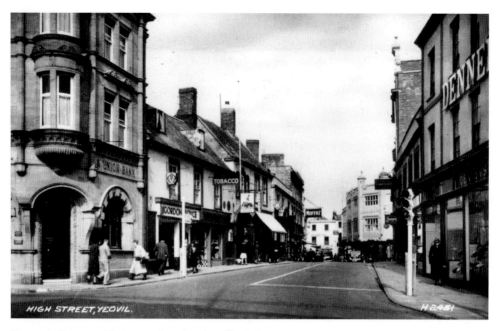

Denner's Corner with the newly erected traffic lights.

Other entertainment during early April was the last dance of the season of the local branch of the Junior Imperial League in the Town Hall to the Imperial Dance Band. The Yeovil Youth Group of the League of Nations Union held a Party and Dance in the Foresters Hall in Sherborne Road on 2 April, when 120 young people had an 'enjoyable evening spent in games, competitions and dancing to the Ambassadors Dance Orchestra'.

The annual meeting of the Princes Lawn Tennis Club was held over Perris's shop in Princes Street (now Ask restaurant). By a majority vote, the Club decided to increase the subscription from 15 shillings to 17 shillings and 6 pence, the Club to provide balls. It was also agreed that the 1935 season should begin on Good Friday.

The *Western Gazette* reported that: 'The "Assemblee Generale" of "Le Cercle Francaise de Yeovil" was held in the Westminster Café on Tuesday evening when a survey of the year's work was given by the President, Mr. L.E. Rees. He spoke with a sense of gratification at the good work of the "Circle" had accomplished during the past year. He felt that it was a great opportunity for those who were interested in the study of the French language to gain an excellent knowledge of the spoken word. The report of the Treasurer showed that the finances were in a good state and that there was a balance of £2 3s in hand.'

Several people had lucky escapes from serious injury when a motorcar travelling from Sherborne Road along Reckleford collided with a Southern National bus crossing from Wyndham Street to Eastland Road. The car bounced off the front of the bus and crashed into the garden railings of a house on the corner of Eastland Road. A lady passenger in the car was thrown out and under the bus, but fortunately suffered only

shock and bruising. The front of the bus was badly damaged, and all the windows of the driver's cab were shattered. Although the bus driver escaped injury, his door was jammed and this had to be cut open before he could be released. None of the bus passengers were hurt and neither was the driver of the car.

On 8 April, the Borough Council carried out a one-day traffic census at Denner's Corner as the first steps towards placing traffic lights at the cross roads of Hendford, High Street, Princes Street and Westminster Street. Men sat in two huts at the junction and recorded the volume and direction of traffic from 7 a.m. to 11 p.m.

The following letter was reported in the *Western Gazette* on 5 April – 'A wooden structure, serving the dual purpose of a pedestrian refuge and a means of diverting traffic, has been placed on the Kingston-Court Ash turning. Considerable confusion seems to have arisen, however, among motorists as to which side they should pass the erection, owing to the omission of notices on the pillar directing traffic to "keep left." When the refuge was first placed in position someone placed a balloon on the top and hanging from the balloon was a small dry battery with the word "Danger" obviously with the object of giving it a "Belisha" beacon appearance. A hurricane lamp with red glass has now taken the place of the balloon, but although it has been there a week the lamp has not yet been lit at night.'

During the first week of April 1935, the Yeovil Police issued a warning to traders and grocers and tobacconists, in particular, about the activities of a man purporting to represent a firm of London tobacconists. The *Gazette* reported that: 'The man, it is alleged, calls on traders, and after obtaining an order for 2,000 cigarettes by stating that in placing the order they will receive an automatic cigarette machine free of charge, obtains a deposit for the order. The man is described as being aged between 40 and 45. According to the police description, he is wearing a dark suit, double breasted dark brown overcoat, bowler hat, black footwear, wears horn-rimmed glasses, and speaks with a London accent. The man is believed to be in the Yeovil district.'

And finally, the *Western Gazette* reported on the final skittles match for the Aplin Cup:

'A close and exciting finish was witnessed on Wednesday evening in the final for the British Legion Club Aplin Cup, at the British Legion Club. The trophy was presented to the Club by Mr. R. M. S. Aplin (a past president) and each year the skittling has been exceedingly keen.

'Nearly 50 teams entered this year and the finalists were Atherton and Clothier "A" and Half Moon Sports, the latter winning by two pins. Atherton's established a lead of two pins at the end of the first hand, and increased it to six. The Half Moon turned the tables in the third hand, and led by five pins. Atherton's regained the lead and led by two pins, which they increased to 15 at the end of the fifth hand. Half Moon knocked 69 in the last hand, and Atherton's were left with 54 to win. They started badly, the first three men knocking only five each. The last man had to get nine pins to win the game, but only obtained six, which gave the Half Moon the victory.' Oh, how I feel for that last man!!

May

MAY 1900

On 4 May 1900 the following item appeared in the Local News column of the *Western Gazette:*

'CRICKET CHALLENGERS WANTED from Clubs of moderate strength in town or country within a radius of 10 miles to play the "Western Gazette Cricket Club Reserves." Send vacant dates to the Hon. Sec., Western Gazette Cricket Club, Yeovil'.

The *Gazette's* first team opened their 1900 season on 5 May with a match against Sherborne 2nds on the Terrace at Sherborne, but lost by 16 runs despite Sercombe's 3 wickets for 7 runs against the home eleven.

In the last match of the 1899/1900 football season, Yeovil Casuals destroyed Street, 14-0, before a large home crowd at their ground opposite Pen Mill Station, and finished joint winners of the Somerset Senior League with Bristol East. The Street team, which fielded only 10 men, were reported to have 'played with dogged persistence and determination until the end. They also took their defeat in a sportsmanlike manner.' Seven seasons later the Casuals would change their name to Yeovil Town F.C.

Painfully on 3 May, eleven-year-old John Hellier of Mill Lane broke his arm when he fell playing football in Wyndham Field.

Possibly, young John would be one of the outpatients treated at Yeovil Hospital, and appear in the statistics for May. In April 1900, nine patients were admitted, there were forty-four outpatients, eight patients were discharged, but sadly three died – at the beginning of May, nine inpatients were being treated. There were gifts to the Hospital from many sources – cream from Messrs Aplin and Barrett, drugs from Messrs Burroughs, Welcome and Co., medicine bottles from Mrs Masters, Mrs Phelips Batten and Mrs Helyar and vegetables, fruit, buns, flowers and newspapers from fifteen other patrons and well wishers.

The School Board met on 3 May with Mr W. Burt in the Chair, and agreed to offer fourteen-year-old Gertie Crotty the post of Monitress at Reckleford School.

In the Borough Magistrates' Court on 2 May, William Chick was fined five shillings and costs for obstructing Sherborne Road for two hours and twenty minutes with his

Corporal Nance wrote home to Yeovil from Ladysmith, seen here during my visit in 1991.

wagon parked under the hedge opposite the Pen Mill Hotel. Described as 'a boy,' George Ricketts was charged with 'leaving a pair of hand trucks for a long and unreasonable time in South Street' and fined two shillings and sixpence.

William Brailey, a leather staker from Worcester, was charged with being drunk and incapable in Middle Street on 3 May. PC Oaten stated that he had seen the defendant staggering in a drunken manner in Middle Street and several people had been forced to get off the pavement to make way for Brailey. Leather manufacturers, Messrs Whitby, wrote stating that they had given the defendant work earlier that week on a letter of recommendation that he was a sober steady man. William Brailey pleaded guilty and was fined five shillings.

During the evening of 2 May, the 1st Yeovil (Baptist) Company of the Boys' Brigade held its annual inspection and gymnastic display before a large audience in the Corn Exchange (destroyed by a German bomb in April 1941). The forty-strong Company was inspected by Major Kelly and then put through Company drill and march past. It was reported that 'The evolutions were executed in a soldier like manner and at the close, the boys were loudly applauded. The bar-bell squad and the dumb-bell squad then went through a number of exercises with great precision. Exercises on the Indian Clubs were given by a number of boys, and this was followed by the stretcher drill which was exceedingly well performed, and watched with great interest.' Following a report on the year's activities from the Company's Commanding Officer, Captain Chaffey, the audience enjoyed: 'A number of limelight views of the Boys' Brigade Camp at Seaton last summer thrown on to a sheet by Mr. W. T. Maynard by means of his lime light lantern, and an interesting account of the week's doings was read by Captain Stewart of the 1st

Yeovil's Years

Sherborne Company. The evening concluded with the National Anthem and afterwards the boys enjoyed refreshments provided by the generosity of Mr. W.T. Maynard.'

Five thousand miles away in South Africa, Corporal Nance of the 18th Hussars sat down and wrote home to his father, Sergeant Major Nance of Ilex House, Market Street. The Corporal had served in the besieged town of Ladysmith and in reporting his letter, the *Western Gazette* wrote that: 'They are not going to send his regiment to the fighting line again if they can avoid it. He has been sent out of Ladysmith to recruit his health. They had plenty to eat, including a few delicacies. They also had a dry canteen, but he complains that things are dear. The civilians in South Africa charge the soldiers twice as much as anyone else, which is poor reward for defending the town for them as they did with practically nothing to eat. Corporal Nance speaks of the gallant way in which Sir George White held Ladysmith, adding that when he cut down the rations it made him cry. The writer goes on to promise to send home his Queen's chocolate when he receives it, and also an old watch he captured off a Boer prisoner. They had not received a quarter of the things sent out from England. Someone above, he suggests, was making a fortune out of them.'

Finally an 'INTERESTING NEW FEATURE' appeared in *Pulman's Weekly News* on 8 May 1900. The newspaper announced that it had 'just completed arrangements by which any reader of this paper can submit examples of handwriting and have his (or her) character and latent talents – or those of any of their friends – correctly described by an eminent London Graphologist entirely free of charge,' and one of the first 'character sketches' was that of 'Pussy Green Eyes (Crewkerne) – This calligraphy shows a fanciful capricious nature, not altogether robust, yet persistent, truthful, freespoken, pretty sociable, but averse to domestic routine. Are ambitious, with easy-going indulgent habits, partial to flowers, books and mimicry. Often dilatory in keeping promises, deliberate in conversation, undemonstrative, generous to deserving objects, like outdoor pastimes and sight-seeing.'

As for 'Glencoe (Yeovil)' this 'character sketch' showed a 'Tenderly, affectionate, and sympathetic nature is apparent here, with blushing modesty. Refinement and sincerity of intention quite above parade or mere display. Not too confiding, but deeply contemplative and deliberate rather than vivacious or loud speaking, delight in literature, music, poetry, and domestic attainments. A trifle assertive tempered, persistent at duties' bequest, and discreet in making lovely presents.'

'DINAH MITE'

On 29 May 1953, the *Western Gazette* wrote enthusiastically about the show being presented by the St Peter's Youth Club:

'72 YOUNG PEOPLE IN
YEOVIL REVUE
St. Peter's Youth Club
Stage "Dinah Mite"

The cast of the popular St Peter's Youth Club revue.

A revue which cannot fail to be a success is "Dinah Mite," Yeovil St. Peter's Youth Club's third public production, which they presented last night (Thursday), at Summerleaze Park School. Further performances will be given tonight and tomorrow night.

Strangely enough, the reasons why this show will get plenty of "credits" are not so much acting, singing or dancing ability – for these, as might be expected with a cast mainly composed of very young children, are limited – but really because of the seventy-two lively youngsters taking part is so infectious that enthusiasm and applause on the part of the audience come naturally.

Local Script Writer

"Dinah Mite" tells the hilarious story of a little girl from the day she won first prize in the baby show to the day she held a ball to celebrate her 21st birthday, writes our representative, who saw the dress rehearsal on Tuesday. Keith Burgess, who wrote the script, helped Mrs W. F. Clark with the production and also took a principal part, must be selected as the show's guiding genius. His script was excellently written, his humour incessant, and his own burlesque as a vicar and a schoolmaster remarkably funny.

Mrs Clark had a far from easy task in training to sing, dance and act in public more than fifty very young girls. Her policy, apparently, was to get parts for every member of the youth club. The production on the whole was hall-marked by the irrepressible keenness of the younger performers.

Principal Role

"Dinah" was played by Gillian Pearce, a perky and coquettish little minx with a roguish twinkle in her eye. She had the knack of looking six years old when she was supposed to be, and also a very sophisticated twenty-one when the occasion demanded. Hers was the only real principal role and much of the continuity depended on her handling of the comic situations.

Comic high spots were shared by Keith Burgess, Gillian Pearce and another excellent impromptu comedian, Ron Batty, who played Mrs Mite, in the best pantomime dame style, and "Billy Ous," a "dim" schoolboy. Jean White was a stately Lady Holman and June Williams a good caricature of a Vicar's wife.

Another "credit" for the company was the designing and making of all the scenery and the costumes in the show. Both these were specially effective, particularly the scenery, constructed by Mr. H. J. Tompkins and Mr. R. A. Batty. Mr. H. J. B. Hughes, assisted by Keith Grant, was in charge of lighting effects. Other help was given by Mrs. H. Tompkins and Mrs. Cleal.

Music was selected and played by Brenda Clark and Keith Tavener, and dances were arranged by Brenda Clark, Jean White and Pat White. Vocal solos, "On wings of song" by Mendelssohn, and "Friend of Mine," were sung by Jean White and Keith Tavener.

The Cast

Other parts were taken by Glenys Gould (Mrs. Bee), Keith Clark (Horace Little), John Creek (Tom Atto), Michael Grinter (Percy Ponger), Derick Rendall (Paul Tall), and Pepe Turner (Gertrude) and Patricia White (Fairy Foxglove). Also in the cast were Doreen Cook, Gillian Elliott, Betty Fisk, Marian Austen, Pat Brophy, Roma Cleal, Joyce Greenwood, Jackie Matthews, Elizabeth Pocket, Sally Darke, Jean Farrant, Pauline Rice, Annett Rogers and David Devoto.

Younger dancers and members of the chorus were:- Susan Hurford, Wendy Hall, Elizabeth Glover, Elizabeth Parker, Jennifer Elliott, Carol Shire, Susan Hill, Jeannette Fitzgerald, Eileen Tate, Cynthia Churchill, Marylin Miles, Kathleen Barnes, Florence Barnes, Rosemary Elliott, Hazel Tetlow, Denise Ralph, Janice Parker, Betty Windsor, Pat Grundy, Diane Elliott, Jackie Creese, Sheila Trott, Jean Barnes, Anne Tompkins, Janet Elford, Janet Neal, Valerie Whitewood. Junior Group – Jenny Darke, Jenny Amatt, Jenny White, Mary Prince, Jean Richards, Valerie Austen, Pauline Mountain, Joan Monhurl, Elaine Wells, Ann Knight, Carol Hyde, Margaret White, Pat Parker, Eileen Hyde, Ann Montacute, Mary Windsor, Stella Moore.'

VE DAY 1945

At the beginning of May 1945, the announcement of the defeat of Nazi Germany was expected at any time, and across the nation arrangements were underway to celebrate Victory in Europe – VE Day – when it arrived. Already Yeovil had prepared

its programme of events, and the pubs had been granted extended opening hours to 11.30 p.m. for the great day.

Monday 7 May was an odd sort of day, because everybody seemed to be waiting for something to happen and for Mr Churchill, the Prime Minister, to tell the nation that the war was over in Europe, but nothing happened. Then suddenly, at 7.40 p.m. in the evening, the BBC announced in a news flash that the Prime Minister would broadcast to the nation at three o'clock on the next afternoon, and that Tuesday 8 May would be Victory in Europe Day and a holiday; Wednesday would also be a holiday.

During that Monday evening cinema goers at the Odeon were watching Alan Ladd and Lorretta Young in a film with the strangely prophetic title of *And Now Tomorrow* and when the news flash was announced, the audience stood on their seats and cheered.

VE Day dawned in Yeovil with flags and streamers decorating the town centre, and a good humoured crowd soon thronged the streets. Many were wearing red, white and blue ribbons, but were out-done by an elderly man who strode about wearing a top hat and a frock coat festooned with Union Jacks. All the town's churches and chapels threw open their doors and the noontime services were packed with worshippers. The Boys' and Girls' Brigades, led by their Band, marched through the street following a service in the South Street Baptist Church.

The VE Day Thanksgiving Service in St John's Churchyard in the afternoon of 9 May 1945.

At three o'clock, Winston Churchill announced in his long awaited broadcast that the hostilities in Europe had officially ceased and an hour later the Mayor, Councillor William Vosper, standing on a platform built on the 1941 bomb site opposite the Midland Bank, addressed a jubilant crowd in the Borough.

The Mayor recounted the events since the war began in September 1939, and paid tribute to the nation's fighting forces and our allies during the past five and a half years. In conclusion, he reminded everyone that the war was still going on in the Far East against the Japanese, and he hoped that when the final victory was won, the world could look forward to a long era of peace and prosperity. As the Mayor ended his speech, the bells of St John's church rang out a victory peal, and the people of Yeovil danced in the Borough or marched with arms linked through the town.

The Mayor spoke again in the Borough at seven o'clock in the evening, and called upon Yeovilians to 'Sing and dance, for this is Victory Day – I want you to enjoy yourselves – well done Yeovil, we can be proud of ourselves!'

Now let the *Western Gazette* recall that May evening of sixty years ago:

'The scenes at Yeovil on the night of VE-Day were unequalled on any occasion within memory. The mood of the crowd was one of unrestrained jubilation. Hundreds whirled around in fantastic dances, jitterbugging, laughing, singing and shouting. Music was played by Bill Kelly and his Band and relayed through amplifiers on a National Fire Service van. Scores linked arms and marched vociferously through the streets. When dusk fell the lights in the streets blazed in the Borough, while in Sidney Gardens and Bide's Garden, high powered lamps strung among the trees gave theatrical beauty to the foliage and flower beds. In the centre of the town St John's grey walls that had withstood bombs in 1941, although some of the windows were damaged, were floodlit. Crowds gathered there, seeking the sense of quietude and peace that were to be found only a stone's throw from the joyous shouts and whirling thousands in the Borough. Tired momentarily with dancing and hoarse from shouting, they lay at ease on the floodlit grass.

'A cheer rent the air as the floodlights were turned on, then the revelry was renewed. The noise of fireworks and thunder flashes mingled with the music and the songs. Hour by hour the crowd thickened. The V.A.D. Somerset/19 members patrolled the town, and several girls who had danced in rings until they were giddy and fainted were revived – only to begin again.

'On and on the band played on and on the dancers danced. Midnight struck. The band had played non-stop since the early evening. They played until they could play no more. The crowd gave them a ringing cheer as they laid down their instruments after the singing of "Auld Lang Syne" and "God Save the King."

'The band went home, but the crowd didn't. From nowhere appeared accordions and hundreds at a time gathered round the single minstrel. Outside the Westminster Bank a large crowd gathered and dancing went on for nearly two hours. Cheering people marched through the streets right up to 3.30 a.m. It was a night to remember!'

At 10.15 in the morning of VE Day plus one, 9 May, crowds lined the streets and cheered the mile-long parade of over a thousand men and women of the three fighting services, Civil Defence, and the United States Army, as led by three bands, they marched

from Sherborne Road to the Huish Football Ground for the Public Thanksgiving Service. Many thousands of townspeople gathered in and around the Huish Ground, and there was cheering and warm applause as the US Army contingent marched in led by Sergeant C. W. Whitaker, proudly carrying the Stars and Stripes.

During the afternoon, crowds packed St John's churchyard for another Thanksgiving Service which was preceded by a parade of over 700 young people representing the town's youth organisations who marched to the church from the South Street car park.

Once again the evening was turned over to dancing, but on this occasion it was at the floodlit Huish Ground where a huge crowd danced to Bill Kelly's Band. There was a concert in the Sidney Gardens given by the Westland Male Voice Choir and the Salvation Army Band played in the Borough.

However, the highlight of the evening (quite literally) was the huge bonfire built on the top of Summerhouse Hill. At ten o'clock precisely the bonfire was lit by Column Officer Charles Mitchell of the National Fire Service, and as the flames roared up they took with them a more than life size effigy of Adolf Hitler, while adults and children danced round the blaze.

For two days across the nation, people danced, sang and thoroughly enjoyed themselves, forgetting, perhaps for a short time, the savage war still to be fought to a conclusion in the Far East, and the shortages and rationing which would continue for a long time to come.

MAY 1932

The first week of May 1932 saw a couple of 'firsts' in Yeovil. Auctioneers Messrs R.B. Taylor & Sons had installed in the Corporation Pig Market what the *Western Gazette* reported to be: 'The first visible weighing machine in England devoted entirely for the weighing of pigs before sale by auction.' After describing the machine and its operation, the *Gazette* informed readers that: 'It is interesting to note that the cattle weighbridge installed for Messrs R. B. Taylor & Son in 1920 in the Yeovil Market was the first visible cattle weighbridge installed by its makers in southern England.' Also in the first week of May 1932, the Great Western Railway Company opened a new passenger Halt at Hendford and all trains on the Yeovil to Taunton line would stop at the single platform. As well as travelling from the Halt to Taunton and all stations in between, passengers could take the train to Town Station or on to Pen Mill. I often used the Halt to take the train to Thorney to go fishing, or down to Pen Mill to catch the Weymouth or Bristol trains. If I remember correctly, the signalman at the Halt would take and issue the tickets. Hendford Halt remained in use until the Taunton line was closed to passengers in the mid 1960s, and the site is now somewhere under the Westland factory complex.

The ancient ceremony of blessing the crops took place on Rogation Sunday when a procession left Holy Trinity Church in Peter Street, crossed South Street and down Addlewell Lane to the Summerhouse Hill Allotments, where the Vicar of Holy Trinity performed the ceremony and offered prayers for all who worked on the allotments.

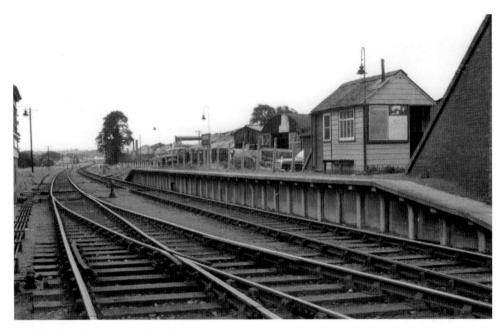

Hendford Halt was opened in May 1932.

On 6 May 1932, the *Western Gazette*, under the headline 'SCHOOL CRAFTS – A Remarkable Exhibition in Yeovil' reported that: 'Handicrafts of amazing variety produced in the schools of Somerset, were shown at an exhibition held under the auspices of the Board of Education at the Central Junior School, Yeovil. It was open only to teachers and others actively interested in education, but it afforded something of a revelation of the work now being achieved in elementary school.' The 'revelation' included a huge relief map of Somerset and the Bristol Channel made of moulded paper, beaten metal work in copper, bronze and pewter, black and white and coloured lino printing, pottery, weaving, and leatherwork from the dyeing to the finished product, carpentry and the manufacture of garden furniture.

The *Western Gazette* also published the following article from *The Motor Cycle* magazine on a controversial speech by the Mayor, Alderman W. Earle Tucker, at the reunion dinner of the Yeovil Motor Cycle Club: 'Back patting, bouquet handing, and fulsome praise (which though admirable for fostering the festive spirit, often look a little insincere in the cold light of day) are such a feature of club dinners that it is quite refreshing to find a speaker saying what he really thinks, even if one does not agree with his opinions. For instance, we have the Mayor of Yeovil saying at a reunion of Yeovil M. C., at which he presided: "I must say you strike me on the whole as being very noisy, and you don't realise the pace you are going at." He then went on to state that he had never heard of any motor-cyclist in a police court admit going at more than ten miles an hour. "I do think manufacturers could improve on designs by which motor-cycle engines are silenced. There is room for improvement," he declared. My correspondent does not tell me how these remarks were received! Still the speaker

did make amends by urging all those who were going to buy new machines to buy British ones. A rather expensive matter just now, methinks, to do otherwise, even if one wanted to!'

In the footballing world, Yeovil and Petters United had just become the 1931/32 champions of the Southern League – Western Section, and had come third in the London Combination Division Two above Bristol City and Bournemouth. On Friday evening 6 May, the full Yeovil and Petters United team went to Crewkerne to play a charity match in aid of Crewkerne Hospital, against Mr R. H. Symon's XI. Over 1,000 spectators watched Mr Symon's team, drawn from players in the Perry Street League, go down 4-1 after putting up 'a good show against their professional opponents.' The Crewkerne Silver Prize Band played selections of popular music before the game and during the interval at half time. After the game the teams were entertained at the Swan Hotel, the headquarters of the Crewkerne Town Club.

The next day, the Glovers played a friendly against Sunderland at the Huish ground, but sadly the 6,000 spectators, many of whom came by special trains, saw the Yeovil men go down 7-2. The *Western Gazette* reported that: 'Undoubtedly Yeovil felt the strain of having played four matches in almost as many days, and the Northerners gained a comfortable victory by 7-2. Sunderland provided some splendid football, of which long passing movements were a feature. Even during the second half, when a torrential downpour swept the pitch, they retained wonderful ball control … After the match the players, officials and directors of the Yeovil and Petters United Club attended a dinner, provided by an anonymous sportsman, at the Three Choughs Hotel. An excellent repast was provided by Mr F. W. Cole.'

And finally, in Division Two of the Yeovil and District League, Yeovil West End beat the *Western Gazette* 3-2 in the play off at Somerton for the League trophy. The game was a close one with both teams drawing 2-2 until just before the final whistle when Yeovil West End slipped the winner into the net. However, there were honours even as both teams were promoted to Division One of the District.

June

JUNE 1869

The first week of June 1869 saw Mr M. Jacobs, the proprietor of the establishment known as 'The Dustpan', Yeovil, announcing in the *Western Gazette* that he was: 'Selling Off his Immense Stock of Household Furniture and Hotel Keepers and Wholesale Buyers will find this a good opportunity of replenishing their Stocks.' At the same time, 'Frederick Dobell, Watch and Clock Maker, Jeweller, Silver Smith, Engraver etc. respectfully announces that he has succeeded to the old established business of his late father opposite Stuckey's Bank and trusts that his unremitting attention will ensure for him a share of public support.'

Elsewhere in the paper, 'An old Established Baking Business of over 40 years' announced that it was up for sale, and 'To Be Sold' were two houses, four cottages and two acres of land adjoining Sherborne Road. F. W. Dodge, the proprietor of 'The Working Man's Cheap Boot Depot' in Silver Street, resorted to verse to attract customers:

> Now winter's blast has gone again
> And spring returned once more;
> With summer hats, and summer coats,
> New boots you'll need I'm sure.
>
> And ladies who are in the fashion,
> And wear their dresses short,
> Must have some tidy boots as well,
> Or they won't look very smart.
>
> Then listen friends, take my advice,
> For boots both good and neat,
> You can't go to a better place,
> Than to DODGE in SILVER STREET.
>

The prices, too, of DODGE'S BOOTS,
Are so extremely low,
They can't be equalled anywhere,
Is a fact that all should know.

.....

Then go at once, and don't delay
And make your choice at DODGE'S SHOP;
And you won't repent your visit friends;
So now my rhyme I'll stop.

Following a meeting of Yeovil shopkeepers on 11 May, it was announced in the *Western Gazette* on 4 June that the town's shops would be closed at five o'clock on Thursdays during the summer months, and 'The Tradesmen's Committee earnestly call on the PUBLIC to ASSIST by their cordial aid in carrying out this desirable object, by making their purchases early on that day.' It was reported in the following week's edition that most of the shops were closed at five o'clock on Thursday 10 June and the few who decided to remain open quickly followed the general example, and closed before half past five.

Several gardens were robbed during the first week of June in 1869. Plants and a quantity of peat were taken from South Western Terrace, some roses and potatoes disappeared from a garden in Wyndham Street and geraniums were stolen from Newton Villas. Superintendent Smith of the Yeovil Police offered a reward for information leading to the successful prosecution of the offenders.

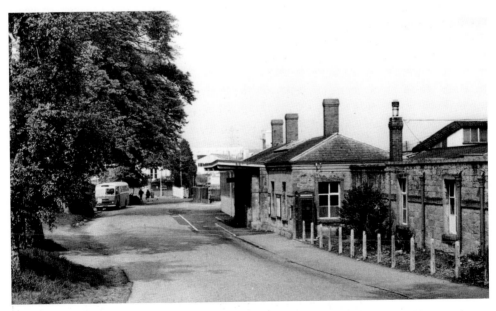

On 4 June 1869 the *Western Gazette* reported that eight glovers left Pen Mill Station, shown here in 1972, *en route* for Gloversville in the United States of America.

Arrangements were reported to be well in hand for the first floral show of the Brympton, Odcombe, Houndstone, Preston and Lufton Horticultural Society to be held in the grounds of Houndstone House by kind permission of Mr T. Sampson. The Bristol and Exeter and South Western Railway Companies had agreed to 'carry passengers from various stations on their lines to Yeovil and back, for single fares, and hopes are entertained that the Great Western Company will act with equal liberality.' Arrangements were being made to convey passengers from the town's stations to the show and there was adequate stabling for those visitors arriving in their own carriages. The Society had also engaged the services of the Band of the Plymouth Division of the Royal Marines under the direction of Mr Winterbottam. The *Western Gazette* was asked to advise its readers that there was no substance in the rumour that 'the show was to be held at Houndstone in order that Mr Sampson may exhibit his own things at the greatest possible advantage and thus stand a better chance of carrying off the greatest number of prizes, and we are authorised to state that he does not intend to compete for a single prize.'

The local gloving industry was undergoing one of its periodical depressions in the summer 1869, and some of the glovers were looking across the Atlantic to the USA and to Gloversville in New York State for a better future. On 4 June, the *Western Gazette* reported that: 'On Sunday last eight glovers left Pen Mill Station by the 11.35 a.m. train for Liverpool en route for Gloversville, Fulton County, State of New York. They were – Messrs F White, from Messrs Ensor's factory; R Fox and E Denham, from Messrs Bing and Anderson's; H Farrant, from Messrs Rawlins and Sons'; J Kibby, from Mr Fooks's; A Slade, from Mr C Raymond's; A Hodder, from Messrs Bide and Hill's; and J Davis from Mr W Raymond's. They were accompanied to the station by a crowd of well-wishers who thronged the large platform and bade them farewell in good old English fashion, the place resounding to cheers and clapping of hands as the train moved off. Two others – Herbert Slade and Charles Hamblin, from Mr Ewens's factory – left the same morning, the former going to Paris, and the other to London. Good accounts, we hear, have been received of the glove trade in the French capital; and some operatives from this district have met with arrangements. The following are amongst those who have recently left the town:- For Paris; Messrs Samuel Yeo and John Bennett. For America:- Messrs Thomas Jeans, Isaac Foot, John Langford, Thomas Ostler and Francis Lewis.'

However, for those who stayed at home, there was the prospect of the 'EIGHTH GRAND ANNUAL DEMONSTRATION OF THE YEOVIL DAY STAR BAND OF HOPE' on Monday 21 June in the field in Preston Road adjoining Grove House. Accompanied by the Brass Band of the 16th Somerset Rifle Corps, members of the Band of Hope would process from Whitbys Wool Yard in Middle Street, through the town to the field and there to enjoy a Public Tea, followed by amusements and 'Rustic Games'. During the evening 'a number of balloons will ascend.'

Finally, the *Western Gazette* announced on 4 June 1869 that its weekly circulation now averaged 15,000 copies and: 'It may be safely assumed that every copy of the paper is seen by five or six persons so that the announcements in these columns is brought to the notice of EIGHTY or NINETY THOUSAND READERS – This is a fact which advertisers should bear in mind.'

MR HENRY PHELPS' LAST RIDE

Early on Tuesday morning, 6 June 1893, Mr Henry Phelps, a man of independent means, and a friend, Mr Tom Thorne, set out to ride to Mudford from his residence in Higher Kingston, where the fifty-two-year-old bachelor lived with his aged mother and aunt. Almost immediately, Mr Phelps' horse bolted and in Ilchester Road he was thrown, dying two days later from a fractured skull.

The inquest into the death of Mr Henry Phelps opened in the Victoria Hall in South Street, on the following Saturday morning, when the first witness, Mr Henry Noke, the deceased's groom, stated that Mr Phelps had come to the stables at about twenty past seven in the morning of the 6 June and told him to saddle two horses. At about seven o'clock, Mr Phelps had returned in company with Mr Tom Thorne. Mr Phelps did not seem the worse for drink, had mounted without assistance, and had perfect control over his horse when the two men set off. About twenty minutes later Mr Thorne had returned and told him of the accident.

Mr Tom Thorne was now called, but was found not to be in the Hall. Police Superintendent Self stated that the witness had been warned to attend, and a constable was sent to his home.

Mr David Wall, of Higher Kingston, was called and stated that he had seen Mr Phelps lead his horse down the drive of the house and mount in the road. The pair then rode off and both men seemed sober at the time; in fact, Mr Thorne 'walked all right'.

By now Mr Thorne had arrived in the Hall, and after being sworn gave his evidence. The *Western Gazette* reported:

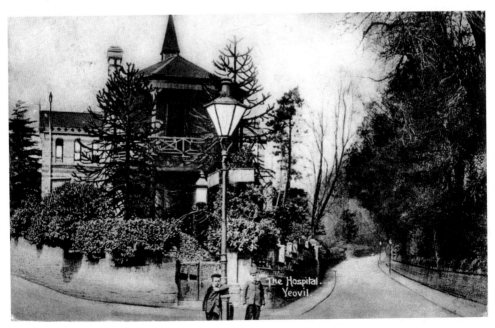

Mr Henry Phelps' horse bolted up Ilchester Road shown on the right of the old postcard.

'Witness – I saw Mr Phelps on Tuesday morning.

Coroner – Where did you see him?

Witness – I saw him in Silver Street.

Coroner – At what time?

Witness – Well, I was with him two or three hours there.

Coroner – In a house or in the street?

Witness – In a house.

Coroner – What house?

Witness – The Half Moon hotel.

Continuing the witness said they left that house at a quarter to five o'clock and went to where the new houses were being built – Father Scoles place (The Avenue). About a quarter past six they went to Mr. Phelps' house, it having been suggested at about four o'clock that they should go for a ride to Mudford. They started for the ride at about seven o'clock, mounting outside the gate. Witness rode a chestnut and the deceased a grey. Witness believed that he started first at a canter. At Mr. Thomas Moore's house, he drew up and said "This is too fast for me." Deceased overtook him and called "Come on." Witness's horse shied at something and swerved, and witness struck his spur into it to keep from going on the pavement. The horse then started off, and was beyond witness's control. It was going so fast that it would not have been safe to turn into Mudford Road, and he, therefore, went straight up the Ilchester Road. When he was at Mr. Batten's gate (now the entrance to Yeovil College) he heard the grey behind him and called out "This is too fast to start with." As Mr. Phelps did not answer witness looked around and saw that he was on the ground. He rode back, the horse which Mr. Phelps had been riding following him, and he found the deceased about fifty yards beyond the Hospital. There were some men with him, and he went for the deceased's doctor.

Coroner – Was Mr. Phelps in a fit condition to go horse riding?

Witness – I never saw him in better form than he was that morning.

Mr. A. J. Davies (one of the jury) – Was there a race? There are rumours that a wager was made as to who could reach Mudford first.

Witness – No, if there had been such a wager I should not have had the fastest horse.'

The next witness, Mr William Sharp of 8 Upper Kingston, stated that just after seven o'clock he had heard horses coming along the street at a tremendous rate, and running out of his house, he saw Mr Phelps and Mr Thorne go galloping past. Mr Phelps was hanging from his horse, and believing something was wrong he ran after him. In Ilchester Road he found Mr Phelps lying unconscious in the road and, with another man, helped carry him into the hospital.

Mr Phelps' medical practitioner told the inquest that he had been summoned to the hospital where he found the deceased, unconscious and suffering from what appeared to be a fracture at the base of the skull. His patient never regained consciousness and died at twenty minutes past six on Thursday evening. The doctor went on to say that about twelve months ago, Mr Phelps had suffered a slight seizure, which had since been followed by several similar attacks.

He had advised his patient not to ride again, and he was aware that the deceased had fallen off more than once due to slight seizures. The horse which Mr Thorne had been riding was given to running away, and the doctor stated that Mr Phelps would not ride it if he could use another.

The inquest jury returned a verdict of 'Accidental Death' and on Monday 12 June 1893, Mr Henry Phelps was interred in the family vault in Yeovil Cemetery.

Reading the report over a century later it is interesting to speculate what the two men were doing wandering around at a quarter to five in the morning after spending several hours in the Half Moon, and then setting out on a ride to Mudford at seven o'clock. And what about the doctor's warning to Mr Phelps, the comments about sobriety, and the rumours of a wager?

THE LATE ADOLPHUS LINNETT

During the years I worked in the old Yeovil Borough Council's Town Clerk's Department, I would spend the occasional lunch time in the strong room reading past Council and Committee minute books, and believe it or not they could be quite interesting! The minute books, which are now in the safe keeping of the Somerset Record Office in Taunton, went back to the early years of the nineteenth century and were hand written by a Council clerk until about 1910, when some began to be typed. However, for some twenty or so years from the late 1880s much of the handwriting was in one distinctive hand which suddenly stopped in the summer of 1912. I presumed that the writer had been taken over by the typewriter, retired or moved on to another job. Subsequently, I found out that the writer was a Mr Adolphus Linnett and a little later I discovered why he had stopped writing the minutes.

In 1886, Mrs Adolphus Linnett joined the office staff of Mr H. B. Batten who, in addition to his legal practice, was Town Clerk of Yeovil Borough Council, Clerk to the Education Committee and Clerk to the Burial Board, and Mr Linnett was engaged primarily in the work of the Borough Council and other public bodies. For many years he held the post of Deputy Town Clerk and on the death of Mr H. B. Batten in February 1912, Mr. Linnett became temporary Town Clerk pending the appointment of a successor. On Wednesday 12 June 1912, the Borough Council decided to draw up a short list of candidates for the vacant office of Town Clerk and the draft minutes of the meeting were written in Mr Linnett's distinctive hand. They were to be the last minutes Adolphus Linnett would write.

Early the following morning Mr Linnett was cycling down Middle Street on his way home to Sherborne Road, when a cat jumped down from the railings in front of Mr Christopher's Photographic Studio, and dashed across the road into the path of the approaching cyclist. Mr Linnett swerved, but his front wheel hit the cat and the unfortunate rider went over the handle bars to land head first on the road. Standing outside his shop, Mr H. E. Higdon witnessed everything and with several passers-by ran to the aid of the crumpled figure lying in the road. They found Mr Linnett unconscious and they gently carried him back to Mr Higdon's shop. When

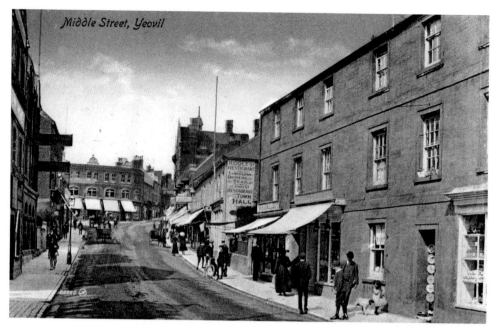

Mr Adolphus Linnett crashed from his bicycle outside the shops on the right of this photograph in 1912.

Dr Colmer arrived he found the unconscious rider to be suffering from a severe blow to the forehead and Mr Linnett was taken to his home in Sherborne Road where his condition began to deteriorate. A specialist surgeon was brought down from London, but after examining the patient he could only pronounce that Mr Linnett's condition was far too grave for an operation and the case was hopeless. Adolphus Linnett never regained consciousness, and died aged fifty-seven years at 3 a.m. in the morning of Saturday 15 June, leaving a widow and four grown up daughters. During his last days, bulletins on Mr Linnett's condition were published outside the Town Hall and he was mourned greatly by the townspeople as a popular and well liked man.

The inquest found that Mr Linnett had died from extensive fractures of the skull caused by 'the unfortunate meanderings of a cat.'

On Wednesday 19 June, Mr Adolphus Linnett was laid to rest in Yeovil Cemetery and the *Western Gazette* reported that it was 'the occasion of a demonstration of affection and esteem on the part of the townspeople. Hundreds of windows were shuttered and the blinds of residences on the route of the cortege drawn.' In addition to his many public duties, Mr Linnett had been an active member of the local Methodist Church, Superintendent of the Pen Mill Sunday School, and worked closely with the Band of Hope Union, the Sunday School Union and the Free Church Council. After the service in the packed Weslyan church in Vicarage Street, the large funeral procession, led by family mourners and the Mayor and Corporation, wound its way up Middle Street, along Princes Street and Kingston to the Cemetery, where the *Western Gazette* reported that over 1,500 people paid their last respects. The *Gazette* also reported that

on the Sunday following Mr Adolphus Linnett's untimely death, all the children at the Pen Mill Sunday School 'were weeping and refusing to be comforted.'

On 8 July 1912, the Borough Council appointed Mr H. C. C. Batten (later Colonel – DSO), to be Town Clerk; the third member of the Batten family to hold this office from the formation of the Yeovil Borough Council in 1854 until his retirement in 1949 when he was succeeded by the late Mr T. S. Jewels.

JUNE 1944

At the beginning of June 1944, the newspapers were headlining the invasion of Europe, and foretelling the final destruction of Nazi Germany. Naturally on 6 June 1944, and the subsequent days, all eyes and thoughts were on the strip of coast across the English Channel, but life was still going on at home, more or less as it always had.

For example, on 6 June – D-Day – Somerset Women's Institutes held a 'local government conference' and looked forward to women taking a more active role on local councils. One speaker stated that if they wanted better housing, sanitary conditions, education, water supplies, recreation centres, playgrounds and such like in the countryside, women should brave the prejudice against them and stand for election. She pointed out that men had been designing homes since 'the year one' and in 1944 were still perpetuating stupidities, 'even putting hot water pipes in larders'; women's common sense was badly needed!

The war was, of course, impinging on everyday life and no more so than in the business of selling groceries. A Yeovil shopkeeper was brought before the Magistrates for supplying soap to the proprietor of a café without the necessary ration documents. To be sent to prison, he told the bench, would be a holiday from his business worries, and pointed out that there were over 7,500 rules about rationed goods laid down by the Ministry of Food. The grocer explained that he did his best to comply, but counting thousands of ration coupons and making returns, in addition to routine work with depleted staff, meant that there could be unintentional oversights. He had been labouring for a long time under considerable difficulties, he had lost his staff of three men, his wife had been ill for eighteen months, and he was left with only a young girl assistant to deal with the issue of 4,000 rations! The grocer and the proprietor of the café, however, were fined £1 each for the offence.

The Magistrates also dealt with nine cases of keeping dogs without a licence; all were found guilty and fined ten shillings each. Two lady cyclists were fined for riding without lights, and a resident of West Coker Road was fined ten shillings for showing the light from a reading lamp during the black-out, despite the claim that it had been switched on by a three-year-old child. However, two summonses against a local publican for failing to sign the register for attending as a fire-guard and performing his fire-watching duties were withdrawn.

The bench was asked to approve the opening of the town's cinemas at 2.30 p.m. on Sundays, instead of 6.30 p.m., as the servicemen visiting the town had nothing to do on those afternoons. The Secretary of the Executive for Entertainment for the

Two pages of the twenty-six-page ration book issued by the Ministry of Food.

Services, who presented the application, stated that there was no question of keeping the men out of the churches or places of worship, but of helping their morale. Despite objections from the local clergy, the Magistrates granted the application, but prohibited the admission of young people under the age of sixteen until 5 p.m. to 'give them the opportunity of going to Sunday School'.

While on the subject of cinemas, what was showing locally during the week of the D-Day landings? The Central Cinema was presenting Irving Berlin's *This is the Army* in glorious Technicolour with the Original US Army Stars and George Murphy, Joan Leslie, Ronald Reagan and Irving Berlin singing My British Buddy. At the Odeon, Robert Donat and Greer Garson were appearing in *Goodbye, Mr Chips* followed by the *Nelson Touch* with Randolph Scott. Rosalind Russell was starring in *The Beautiful Cheat* at the Gaumont.

On Sunday afternoon, 4 June, at St Andrew's church, a Bishop's Chair, made of oak and carved by Raymond Brothers of Manor Road, was dedicated by the Vicar of Yeovil, the Revd E. Mortlock Treen. The chair bore the inscription: 'Given for the service of God and in grateful remembrance of Maud Josephine Paynter by the teachers, old scholars and children of St Andrew's Sunday School.' For many years, Mrs Paynter was the Sunday School Superintendent.

With so many men in the armed forces and the great need for war production, there was plenty of work for women, with advertisements for all sorts of jobs – one called to Women of the District to take part in the War Effort and 'Work on Aircraft Locally'.

They were asked 'Can YOU come Full Time? If not, come Part Time' for the many interesting and worthwhile jobs.

However, life was not all work, and if you felt like a night out, there was the Home Guard Dance at East Coker Hall to Harry Virgin and His band on Friday 9 June; no doubt there was a lot to talk about that evening.

During 1943 and the early months of 1944, American troops poured into the area for the build up to the invasion, and in the immediate period it seemed that jeeps, lorries, half tracks, guns and assorted vehicles were parked on every square yard ready for D-Day. The GIs in their smart uniforms filled the pubs and cinemas, and to my generation of small Yeovilians they were a never ending source of chewing gum, candy and other assorted goodies.

And finally, the film showing at the Carlton Cinema in Sherborne on Tuesday 6 June 1944 was *So Ends the Night*, which seems appropriate for the day on which the long awaited liberation of Europe began.

July

JULY 1854

On 3 July 1854, the Royal Assent was given to the Yeovil Improvement Bill and Yeovil became a Municipal Borough, the culmination of the lengthy campaign to provide the town with a proper local government. However, the new Council established under the Act of Parliament would not be elected and take office until the following November. In the meantime, apart from a small paragraph in the *Western Flying Post* of 27 June reporting that the Bill was awaiting the Royal Assent to become law, the columns of the local press over the next few weeks were concentrating on more exciting matters.

One was the exhibition in the Borough of a 16 ft Grampus Whale caught by John Rockett in his mackerel net off Burton Bradstock, and another story concerned a young man called Hull who, following his marriage earlier in the day, had fallen 18 ft down into Mr Vinings Mudford Road quarry on his way home from the Hollands Inn. It was reported that the bridegroom had spent his wedding night in bed very badly bruised, attended by Doctor Tompkins!

A tragedy was averted in Watercombe, when some mowers returning home from the fields at about half-past eight in the evening saw smoke coming from a cottage, and breaking into the building rescued three young children, all under six, from the blaze which was quickly extinguished. Taking up the story, the *Western Flying Post* wrote that the children had been locked in the cottage by their mother, and: 'It appeared that that one of the children had been playing with a box of lucifer matches, and hammering them until they caught fire. The room is not ceiled, and the thatch of the roof quickly ignited, and but for the casual passage of the mowers, the whole place must have been destroyed. One of the children had crept under the bed, another was too young to get out of bed, and the third was too frightened to know what to do. The occurrence should operate as a warning, as the consequences might have been most melancholy.'

No doubt the mother had a nasty shock and learnt her lesson as doubtless George Frost of the Pen Mill Inn did when the Town Magistrates fined him 10 shillings and

The scene looking down Hendford from Princes Street in the 1860s is little changed from July 1854.

costs (a labourer's weekly wage) for keeping his pub open at four o'clock on Sunday afternoon during Divine Service.

Yeovil Midsummer Fair was described as a very good one, although the quality of the cattle was not up to the usual standard of previous years. However, sheep made up both in quality and quantity. The *Western Flying Post* reported that there were plenty of good side shows and the town shopkeepers had 'dressed out their establishments to the best advantage; conspicuous amongst them was the aspect presented by Mr Curtis's basket establishment.'

However, Mr Curtis's efforts to promote his business resulted in George Brooks appearing before the Town Magistrates charged with assaulting John Tarrant, described as a haircutter of Middle Street. The bench was told that Brooks was employed by Mr Curtis, who occupied a shop opposite the hairdresser's, to distribute and paste up advertising bills around the town. Basket making was also carried out in parts of John Tarrant's premises, and on the day of Yeovil Fair, Brooks had fixed one of his employer's bills on a basket displayed outside the hairdresser's shop and another on a board beside it. Mr Tarrant told the magistrates that he had repeatedly ordered George Brooks not to do this and 'some complimentary language' had passed between them. The *Western Flying Post* recorded that Mr Curtis, speaking for his employee, told the bench: 'That on the fair day, as fast as his bills were put up round the town, the complainant's boy tore them down; and that he (Curtis) and his apprentices, and even his customers, could hardly go in or out without being annoyed on the part of Mr. Tarrant. From the manner in which the parties regarded each other, the bench thought they could perceive the jealousy of rival tradesmen, but Mr. Curtis begged to say that the plaintiff "was quite beneath his notice as a tradesman." No assault being

shown, case was dismissed, the defendant promising not to obtrude his bills upon the complainant's premises.'

To local people there were probably much more exciting things to dwell on than the basket makers' problems, or the passing of the Improvement Bill, in the first week of July 1854. There was, for example, the railway excursion to Weston-super-Mare, which to many Yeovilians would seem a far off place in those days. Nearly 600 excursionists boarded the train at the new Hendford Station, another 100 were picked up at Montacute, 287 at Martock, 200 at Langport and 60 more at Bridgwater; in all, over 1,200 arrived in Weston-super-Mare. It was reported that: 'The day being fine, a very pleasant trip was enjoyed, the excursionists, a large proportion of whom consisted of the working classes, conducting themselves in the most orderly manner.'

And finally, a look at the weather during this first week of July, 1854. It had been unseasonably cold and damp for several weeks and, on 4 July, the *Western Flying Post* reported that: 'Haymaking has been commenced in the sunny intervals, but rain yesterday and for the last several days will do the hay much damage. It is feared that the weather is of the kind most promotive of the potato disease.'

THE WILD WEST COMES TO TOWN

Early in July 1903, posters began appearing all over Yeovil – 'Buffalo Bill's Wild West Show' was coming to town. There would be genuine Indians, real cowboys and cowgirls, US Cavalry, English Lancers, Russian Cossacks, Rough Riders, Mexican Ruralies, crackshots, exciting battles and episodes from the Wild West! The Wild West Show and Congress of Rough Riders of the World, personally led by Colonel W. F. Cody, 'Buffalo Bill' the 'One Grand Ruler of the Amusement World,' would thrill young and old alike for one day only on Saturday 24 July in the Agricultural Show Ground at Seaton Road.

Early on Saturday morning, four special trains drew into Hendford Station and disembarked four hundred horses and seven hundred people of all nationalities, watched by a large and enthusiastic crowd lining the route to the Show Ground. With military precision, the great arena measuring 325 ft by 500 ft was laid out with covered seating for nearly 15,000 spectators, and at eleven o'clock the Famous Cowboy Military Band began the day's events, with the Preliminary Open Air Concert.

Guess what – it poured with rain off and on all day, but this did not dampen the spirits of the huge audiences for the two shows who kept dry under the large waterproof awnings. They came from town and country, in special trains, on foot, bicycles, carriages, wagons and in the rare motor car. By the end of the day over 25,000 people had seen the show and: 'It was no exaggeration to say that the town had never been so full of people before,' exclaimed the *Western Gazette*.

Both performances were opened with the overture 'Star Spangled Banner' played by the Cowboy Band, followed by the 'Grand Review of the Rough Riders of the World' led in person by Buffalo Bill. Group after group of riders galloped into the arena; there were famous Indian tribes of the Western Plains – the Brule, Ogallalla,

The four special trains carrying the Wild West Show would have been shunted into Hendford Goods Station along the rails on the left of the 1964 photograph.

Uncappapa, Sioux, Cheyenne and Arapahoes, followed by Mexicans, Cossacks, Arab Horsemen, Cowboys, Rough Riders, English Lancers, the Sixth and Tenth US Cavalry and Western Girls. There followed exhibitions of riding and a display of canon firing by US Artillerymen. A train of covered wagons drew into the arena and into a circle as it was attacked by Indians. However, after a gallant defence by cowboys and wagoners, the attackers were driven off. Indians then pursued a Pony Express rider who outrode them and safely delivered his precious mail. The Deadwood stagecoach, mud spraying from its wheels, drove wildly into the arena followed by a band of whooping Indians. Skidding to a halt, the passengers blazed away at their attackers with rifles and revolvers until Buffalo Bill and his band of cowboys came charging to the rescue in true Wild West style. There was 'an incident of ranch life in the West' when a cabin was attacked by a band of Indians on the warpath and once again the cowboys arrived in the nick of time to save the settler and his family.

Buffalo Bill gave an exhibition of rifle shooting on horseback, smashing glass balls thrown into the air as he galloped past. Cossacks came in at full gallop, some standing on their heads on their horses' backs, others hanging under their flying steeds. Two western American girls raced each other, cowboys galloped around at full speed picking up handkerchiefs, lassoing horses and riding bucking broncos. The 'Celebrated American Marksman' Johnnie Baker, standing on his head and from other strange positions, shot up targets in all parts of the arena.

The *Western Gazette* reported on re-enactments from the battle of San Juan Hill in the recently fought Spanish-American War in Cuba: 'Men who had actually taken part in the fight engaged in a couple of elaborate spectacles, the first depicting the time

before the battle, and the second the storming of the hill. Detachments from Roosevelt's Rough Riders, Twenty fourth Infantry, Ninth and Tenth Cavalry, Grime's Battery, Garcia's Cuban Scouts, Pack Train etc. etc. were introduced. Tents were pitched, camp fires lighted for the bivouac and the soldiers having shown some of the sports in camp, tenderly sang "The dear little Shamrock." The contrast came with the bugle call to arms, volley firing and independent shooting and the use of a machine gun, the hill being successfully "stormed" by the infantry.'

Continuing with the military theme, English Cavalrymen who had seen active service in the Boer War in South Africa, and detachments of the 10th US Colored Cavalry and veterans of the 6th US Cavalry, paraded the arena and demonstrated their skills.

Each performance concluded with a grand finale of the entire cast galloping around the arena to the thunderous cheers and applause of the audience.

A variety of side shows were presented in a large tent outside the arena including Hassam Ali, the 8 ft 2 in giant; Walters, the Blue man; Shanghai Chinese Troops of gymnasts, acrobats, conjurers, and the only little-footed Chinese ladies ever seen in Great Britain; Giovanni's performing cockatoos; Griffin, necromancer and sword swallower; Herr Rhoatig, wonderful manipulator of cigars etc.; Mlles. Octavia, fearless serpent enchantress; Alfonso, human ostrich; and Professor Sackette's Military Band.

The *Western Gazette* reported that: 'Through the thoughtfulness of the Mayor, the lamps in the vicinity of West Hendford were allowed to remain lighted for a longer period than usual for the convenience of the people and the show employees.'

So ended an exciting day in Yeovil in the summer of 1903 but there was a postscript to these events forty six years later in the *Western Gazette* of 4 March 1949:

'Former Member of Buffalo Bill Show

A native of South Petherton who emigrated to Canada and went on tour for many years as a member of the famous Buffalo Bill Wild West Show, Mr Joseph Reyland, died on Saturday at the home of his daughter and son-in-law, Mr and Mrs S Tucker, at 3 Fielding Road, where he had lived for 15 years. A veteran of the Boer War, Mr Reyland enlisted in the Canadian voluntary force at the outbreak. While in England Mr Reyland was a farm worker at Ash and Lambrook but latterly was employed by the Bristol *Evening Post* in Yeovil as a newsvendor. He was 76.'

HOLIDAYS AT HOME WEEK 1943

Travel during the Second World War could be long, tedious and very difficult. Petrol for private use was tightly controlled and non-existent for recreational motoring; also the war effort took priority on rail and road. The discomfort of rail travel can be imagined when a check at Waterloo Station during the August Bank Holiday weekend in 1943 revealed that over 1,300 people had travelled in a main line train which normally carried 460.

Holidays at Home was a national scheme to provide entertainment for the many people who could not, or did not wish to, get away during the usual summer holiday

The United Service and Carolare on the Sunday evening was held in Sidney Gardens.

weeks. The Yeovil Holidays Amenities Committee worked hard to organise a varied programme of entertainment and designated the week which ran from Saturday 31 July to Sunday 8 August as 'Holiday at Home Week 1943.'

On Saturday 31 July, between 700 and 800 people paid their one shilling (5p) entrance fee and attended the Great Sports Attraction on the Westland Sports Ground. The sports included foot races, relay races, cycle races, long and high jumps and tugs-of-war, with competitors entering from the local civilian population and the army at Houndstone Camps; soldiers won the flat mile race and the men's relay, but the Yeovil Police team won the tug-of-war. The children enjoyed a Punch and Judy Show presented by Corporal Stafford the well-known 'Uncle Tommy' on West Regional Radio.

A concert was given in the Assembly Rooms by the Fleet Air Arm Dance Orchestra who presented 'Band Waggon' in aid of the Merchant Navy Comforts Fund. Guest artistes included BBC pianist Ernest Lush and Johnny Fanton, formerly resident guest artiste with the Columbia Broadcasting Company; Paddy Dolan and 'Chips' Chappell provided the comedy routines.

A full programme was arranged for Bank Holiday Monday, 2 August. At 2.30 p.m. Westlands played Yeovil in a cricket match on the company's sports ground off Westbourne Grove – Westland won by four runs. A Monster Whist Drive was held at Huish Junior School at half past seven in the evening, and there were dances in Summerleaze Park School hall (now Parcroft), music by Billy Kelly and Orchestra, and at the Assembly Rooms with the Divisional Dance Orchestra directed by Mons. Paquay.

However, the highlight of the day, a Speedway Meeting on Mr Chudleigh's field at the Pen Mills, which included a Ladies Pillion Event and a Chance for an Enthusiast,

was cancelled at the last moment due to the non-arrival by rail of the racing fuel. During the day, Mr Schofield, the organiser, had toured the local railway stations trying to find out what had happened to the precious petrol, and had tried unsuccessfully to obtain supplies from local petrol dealers.

On Tuesday 3 August, Grass Royal School hall was filled to capacity, with many people standing, for a two-hour entertainment presented by the Westland Players and an ENSA party (Entertainments National Service Association). The Westland Players performed a farcical comedy 'Brown with an E' which was reported to have 'harmonised well with the holiday mood of the audience.' ENSA presented instrumental music, songs and dances described as being 'both "hot" and "sweet"' – Lena Fordyce danced and Shenton Harris sang.

A large crowd turned out at the Huish Football Ground on Wednesday afternoon to watch an exhibition baseball game by two visiting teams of American servicemen. In the evening the Americans drew another large audience to the Assembly Rooms for a concert of Spirituals and Gospel songs followed by a 'jam session' from The Rhythm Boys.

Over a thousand people attended a horse and pony gymkhana at the Huish Football Ground on Thursday afternoon. Despite the entries being limited to horses and ponies kept within fifteen miles of Yeovil because of transport difficulties, the twelve events attracted 182 entries. No professional riders took part but the standard of jumping was reported to have been very good on the slippery course; the young riders were said to have done well in the conditions. The Sherborne Boys' Brigade Band played selections during the afternoon. On Thursday evening an 'Under Twenty's Dance' organised by Yeovil Junior Youth Council, with Mr Jack Willey as Master of Ceremonies, was held at Grass Royal School, and Ron Webb's Savoy Orchestra played at the 'Popular Dance' in the Assembly Rooms – admission three shillings (15p) – Forces two shillings (10p), all proceeds to the Red Cross Prisoners of War Parcel Fund.

On Saturday afternoon, 7 August, 'A Great Children's Fancy Dress Parade and Competition' assembled in Sidney Gardens at half past one, and at two o'clock the eighty entrants marched behind the band of the 1st Yeovil Company of the Boys' Brigade to the Huish Football Ground. The prize winners were: A Lord Mayor, a Schoolmaster, Modern Girl, Eighth Army, A Squander Bug, Save for Victory, John Bull, Wooden Soldier, Salvage and the two Prettiest Children prize winners were Gypsy Girl and Puck. The parade was followed by school children's sports with some 280 entries. The Yeovil and District Horticultural Society, the Town Allotments Association, Somerset Beekeepers Association and Yeovil Cage Birds Society held an Open Show of vegetables, fruit, flowers, honey and cage birds on Saturday afternoon in the South Street Baptist Sunday School Rooms, with 422 entries. Several hundred people visited the show which raised £110 for the Red Cross Prisoners of War Parcels Fund. The last dance of the Holiday at Home Week 1943 was held in the Assembly Rooms with Billy Kelly and his Orchestra providing the music and the final event was a United Service and Carolare on Sunday evening in Sidney Gardens, where a section of the Yeovil Philharmonic Society accompanied the hymn singing.

JULY 1916

When Yeovilians read their *Western Gazette* on Friday 7 July 1916, the First World War would soon be entering its third year, and they would have been cheered to read of sweeping British successes, brilliant trench raids, fierce onslaughts, dauntless bravery, together with the surrender of thousands of German troops. However, during the weeks and months to come, it would become apparent that the great battle, which had just begun and which would go down in history as the Battle of the Somme, was far from the brilliant sweeping successes being read about in Yeovil on that Friday in the first week of July.

Far from the battlefield in that first week of July, the Yeovil High School for Girls held its annual sports on Wednesday 5th in the school grounds in The Park, and it was reported that there was some excellent running and jumping. The competition between the school forms was described as 'spirited' and ended in a victory for Form V. However, no prizes were awarded as the competitors voted for all the money collected for the sports to be given to the fund for English Prisoners of War in Germany.

On 4 July, an American Sale drew a large and enthusiastic crowd to the grounds of Swallowcliffe in Kingston, the home of Mr F. Whitmarsh Mayo, to raise funds for the Swallowcliffe Patriotic Working Party. The *Western Gazette* reported that: 'The stalls were laden with fruit, cakes and miscellaneous articles and the sale was a great success.' Tea was served on the tennis lawn.

The Yeovil Patriotic Fête Committee met in the Municipal Offices on Wednesday evening, 5 July, to discuss holding the event at Newton Park during the coming August in aid of the Yeovil Hospital and the Yeovil Red Cross Hospital. A provisional programme was agreed to include athletic sports for old and young, swimming races and diving in the River Yeo, pony jumping and donkey racing, platform entertainments, side shows and 'varieties of various descriptions.' The Committee decided that both fields would be used on each side of the river.

The scholars of the Baptist Sunday School had their annual treat on 5 July, and St John's Church Sunday Schools held theirs the following day in a malthouse near the Clarence Street Brewery.

The Revd A. J. Waldron gave a lecture at the Albany Ward Palace Theatre in the Triangle, on 'What I saw in France and Serbia' illustrated by 150 slides taken on the French and Serbian battlefields.

At the Nautilus Works in Reckleford (now the bus garage) Mr Ben Jacobs was presented with an Illuminated Address and a £100 War Loan Bond by the Directors of Petters Ltd, in recognition of his twenty-one years service with the company, and for 'the valuable services rendered by him in connection with the design of the first Petter oil engine in 1895.'

Orders for the Volunteer Training Corps published in the *Western Gazette* for the week ending 8 July were:

'Sunday – Fall in at the Territorial Hall at 12 noon and march to Sherborne to take part in a military parade. Men have the option of attending an evening concert on returning to Yeovil after tea. Cyclists can take their machines and will march at the head of the column to Sherborne.

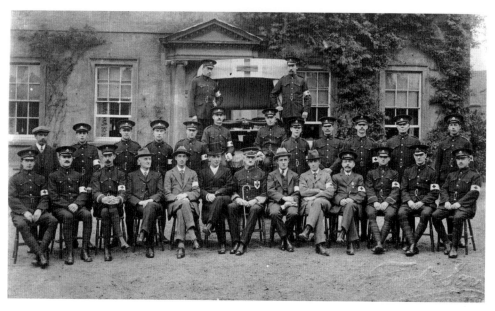

Doctors and members of the Men's Voluntary Aid Detachment with their ambulance.

'Monday – Machine gun section at 8pm.

'Tuesday – Parade in uniform. Field operations. 7.45pm sharp.

'Wednesday – Recruits drill at 8pm.'

The Tuesday field operations involved the Volunteer Training Corps and the Men's Voluntary Aid Detachment in a combined scheme in Barwick Park. The *Western Gazette* reported that: 'The V.A.D. and the V.T.C. met at the Town hall and marched up Hendford Hill to the Park. Here the Volunteers carried out an attack, and their supposed casualties were promptly dealt with and conveyed to a temporary dressing-station by the stretcher squads of the V.A.D. After the operations Col. Trask congratulated the Volunteers on the way they had occupied such a wide front with a small number of men and reserves, and the V.A.D. on their efficient bandaging and general work. The two detachments formed up and returned to their respective headquarters.'

Meanwhile on 7 July, across the English Channel in the real war and along with tens of thousands of their fellow countrymen, Yeovilians were fighting and dying in the trenches of the Western Front. At 7.30 on the morning of Saturday 1 July 1916, under a clear blue sky, some 750,000 British and French soldiers climbed out of their trenches and attacked the German positions on the Somme. By the end of that summer day, the British Army had suffered over 58,000 casualties, a third of them killed, and more casualties than on any other day in its history. Amongst the dead and missing were Yeovilians Private Albert Helyar from 25 Great Western Terrace, and Private Bertie Chant from 45 Queen Street, and Corporal Reginald Pennell, late of 154 Park Street, would die on 2 July from wounds received on the 1st; all three young men were serving in the First Battalion of the Somerset Light Infantry. The First and Eighth Battalions of the Somersets had gone over the top on 1 July and between them lost

forty-four officers and 863 other ranks killed, wounded or missing on that first day of the Somme. Albert Helyar is remembered on the great Thiepval Memorial to the Missing, together with the names of 73,367 men who died on the Somme and who have no known graves. Bertie Chant lies in Sucrerie Military Cemetery, Colin Camps, Somme, and Reginald Pennell in the Couin British Cemetery, Pas de Calais. On Sunday evening 9 July, the first wounded from the Battle of the Somme arrived at the Red Cross Hospital in the Newnam Memorial in South Street and the *Western Gazette* reported that: 'A large crowd witnessed the unloading of the stretchers and commented on the careful handling of the wounded men by the V.A.D.'

August

AUGUST 1942

In the first week of August 1942, our nation had been at war with Nazi Germany for nearly three years, and there was no end in sight. However, despite the difficulties and worries of the time, Yeovilians carried on as best they could.

The *Western Gazette* reflected the 'carry on' spirit when it reported that following hard work by local 'enthusiasts', a colony of red squirrels had been re-established in Ninesprings. The Education Committee approved a scheme for building a central kitchen in Eastland Road to provide dinners for Yeovil Elementary School Children at the six dining centres in the town. The hourly wages rate for kitchen maids would be eleven and a half pence (approx 5p), cooks, one shilling and six pence (about 7p), and assistant cooks, three and a half pence (3p). On 4 August, Mr Arthur Newton, the chemist, celebrated fifty years in business in Hendford, having opened his establishment in 1892.

Yeovil Bowling Club beat Westlands by 7 shots at the Westland rink on 1 August, and there was a good turnout during the week at the Yeovil Club's rink to compete in the 14 games for the E A SHIRE Trophies. At cricket and at camp, the Yeovil Home Guard Company, playing at Timberscombe, beat the home team 55 runs to 76.

With the wartime shortages and following a request from the Ministry of Food, the Yeovil Wartime Dairymen's Association was set up to prepare and submit a scheme for the rationalisation of retail milk deliveries in the town to ensure the 'economic distribution of milk and the concentration of manpower, transport and associated materials'.

On 7 August, the *Western Gazette* reported that men not already engaged in fire guard duty or other part-time national service would soon be enrolled under a new compulsory order to carry out fire guard duties and, in the coming week, the Government would make an order requiring all fire guard training to be compulsory. All men born in the first half of 1924 were required to register for military service before the end of August.

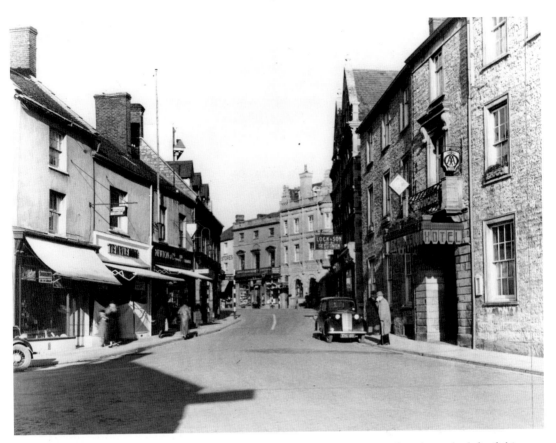

Celebrating his fifty years in business in 1942, Mr Arthur Newton's shop is on the left of this photograph of Hendford, taken about 1938.

The cinemas were keeping spirits up with *The Big Fella* at the Central Cinema; *A Night in New Orleans* and *These Kids from Town* at the Odeon, and down at the Gaumont in the Triangle, Tommy Trinder was starring in *The Foreman Went to France*. The National Savings Committee's Mobile Cinema talent spotting competition 'Let the Children Sing' held its Grand Final in the Borough on Saturday morning, 1 August.

During 1942, the opportunity for holidays away from home could be quite limited, and 'Home Holidays' was the national scheme to provide entertainment for the many people who could not get away because of the difficulties in travelling and the closure or restriction of holiday beaches and resorts. Here in Yeovil, the town's 'Home Holidays' ran for a month from mid-July to 16 August, and during the first week of August, the local organisers had arranged a variety of events beginning on Saturday afternoon with a Children's Fancy Dress Parade from Sidney Gardens to the Huish Football Ground, followed by Children's Sports. On Saturday evening there was a dance at Grass Royal School organised by the Air Raid Precautions Social Committee with dancing to the Westland Dance Orchestra, and over 200 danced to the Blackmore Vale Orchestra at the Wessex Electricity Company's evening dance at Summerleaze

Park School (now Parcroft). On Sunday 2 August the Band of the Czech Forces gave an afternoon concert in Sidney Gardens.

August Bank Holiday Monday saw a full programme, with an Open Athletics Meeting at the Westland Sports Ground, and the Wessex Electricity Company's cricket match and athletics meeting with side shows was held on the Mudford Road Playing Fields. An evening's open air dance followed at the Playing Fields, and another dance was organised by Wessex Electricity at Summerleaze Park School with dancing to Mons. Paquay and his Band.

On Tuesday evening over 400 people packed into the Public Baths in Huish to enjoy an Inter-Service Swimming Gala which included a demonstration by the local military of transporting wounded soldiers across rivers and how to jump into water fully equipped from a height of twenty feet and swim sixty yards. Grass Royal School was crowded for an E.N.S.A. (Entertainments National Service Association) concert with a cabaret show accompanied by Billy Kelly and his Westland Dance Orchestra.

At 7.30 on Wednesday evening 5 August, the Yeovil National Fire Service Concert Party performed to a large audience in Sidney Gardens with Fireman Whitmarsh presenting some 'of his amusing sketches'. At ten minutes past nine o'clock, the air raid warning wailed across the town, the 268th since the war began, and four minutes later two German Focke-Wulf (FW) 190 single engine fighter-bombers roared out of the east and flew low across the town with guns blazing. Each 190 dropped one 500kg bomb and was gone. One bomb exploded in the gardens at the rear of Nos. 13, 14 and 15 Gordon Road and Nos. 2-8 (even) Grass Royal making a crater nine meters wide by two meters deep, demolishing two of the houses in Gordon Road and leaving others badly damaged. The second bomb exploded in Dampier Street, destroying eight houses and badly damaging many more in the vicinity. When the 'all clear' sounded half an hour later, two Yeovilians were dead and twenty-six injured, one of whom, an elderly lady, would lose her fight for life on the following day, bringing the death toll to three. The 'hit and run' raid also left fifteen houses destroyed or damaged beyond repair, and over 970 damaged. The blast scars from the bomb on Dampier Street can still be seen of the east wall of the Yeovil Centre (former Reckleford School).

Wartime censorship would only permit bare details of air raids to be reported and on Friday 7 August 1942, the *Western Gazette* reported that: 'Two German fighter-bombers, flying a little above house-top height, bombed and machine-gunned a West Country town in daylight on Wednesday evening. High explosives did damage to property in a residential area. There were some casualties, including one or two fatal.'

Spirits had to be kept up and the pages of the *Gazette* continued to cheerfully report on the events of 'Home Holidays' week, with more concerts, dances and sports taking up several columns of the 7 August edition. Looking back from over sixty years through these columns, the headlines 'YEOVIL HOLIDAY EVENTS – BIG CROWDS AT ENTERTAINMENTS', mask the horror and fear of those few minutes past nine on that Wednesday evening in August 1942. Mercifully these would be the last bombs to fall on Yeovil.

VJ DAY 1945

On Friday 17 August 1945, the *Western Gazette* reported that the announcement on midnight on Tuesday 14 of the surrender of Japan: 'Caught the majority of people in the South and West unprepared for the immediate celebration of the end of the war. Comparatively few of the thousands of people who, for days, had so anxiously awaited the great news heard the Prime Minister Mr. C. R. Attlee give the signal to all to "relax and enjoy themselves in the knowledge of work well done". Only in towns where social life is continued till a later hour was there immediate reaction to the relief which the announcement brought and quickly there were scenes of spontaneous rejoicing in the streets and in private houses. The majority of people were unaware of the return of peace until the first of the VJ Days was fairly well advanced. Then the preparations of local authorities and householders were accelerated and soon scenes reminiscent of VE Day were markedly in evidence. Throughout the South and West the celebrations were on much of the same scale and form as on the earlier occasion –thanksgiving services, ceremonial parades and music in the daytime, with the climax of fireworks, bonfires, the floodlighting of historic and public buildings, and dancing and unrestrained merrymaking in brilliantly lit streets and squares.

'Amid all the rejoicings there was grateful remembrance of the glorious part which the Hampshire, Dorset, Somerset and Wiltshire Regiments had played in the defeat of the enemy.'

Once again the *Western Gazette* caught the mood of the time in its report on the events of VJ Day as they unfolded in Yeovil on that momentous occasion.

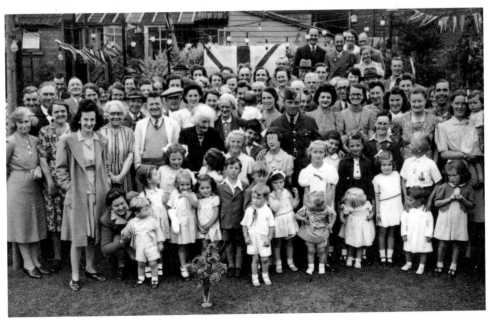

The street party held in the garden of 37 Orchard Street to celebrate VJ Day.

'Though there were remarkable scenes of joy and thanksgiving in Yeovil, there was no repetition of the wild hilarity which marked the end of the European war. Many workers who had not heard the radio announcements started out for work as usual. Townspeople were early astir, and hurriedly put out flags, bunting and streamers. Housewives formed long queues for food, but the longest queue was in Middle Street for fireworks.

'The Mayor and Corporation attended a thanksgiving service conducted by the Vicar of Yeovil (Preb. H. Mortlock Treen), at the Parish Church and the service was relayed to a gathering outside. The bells rang out their joyous peals throughout the day.

'Over 8,000 assembled in the Borough on Wednesday evening and were addressed by the Mayor (Mr. W. S. Vosper), who asked them to remember with reverence and pride those who had fallen – both Servicemen and civilians – and those who had been maimed or wounded or were prisoners. He paid tribute to the work of the Forces and Civil Defence, and other services, and expressed the fervent hope that all would now be allowed to devote their thoughts and energies to the creation of a structure in which all people will live in real peace, happiness and prosperity.

'Public houses which had been granted an extension until midnight were forced to close their doors considerably earlier through lack of supplies. In some cases "Sold out" notices appeared before 10 o'clock.

'The Salvation Army gave a performance in Bide's Garden in the evening.

'Bill Kelly's Band provided music in the Borough, and there were boisterous scenes as the night wore on. Hundreds of people were singing, shouting and dancing. Floodlights blazed down until well after midnight and crackers, rockets and thunderflashes provided a constant succession of bangs and explosions. Two or three children had eye injuries – fortunately not serious – as a result of explosions. The beautiful old church stood floodlit in all its grandeur, and provided welcome solitude and peace only a few yards away from the dancing and singing crowds. There were also illuminations in Bide's Garden.

'An emergency centre manned by women members of the ladies' V.A.D. under Commandant Miss K. Marsh, at the Police Station dealt with a number of cases of fainting, and ambulances had several times to make their way through the crowd. Music came to an abrupt end at 11.40 when the wires from the microphone to the loudspeakers around the Borough were torn away but the crowd did not disperse until nearly three. An impromptu "band" played request items from the bandstand. A bonfire on the Mudford Road Playing Fields could be seen for miles around.

'On Thursday night crowds again filled the Borough, and singing and dancing went on till late, though the scenes were less boisterous. Again, public houses had to close early. Bells rang out throughout the day from the Parish Church.'

The town's children enjoyed parties during the days which followed, and out came the hoarded goodies to give them a time to remember. I retain a very fond memory of the Orchard Street party held on our back lawn at number 37. We had tea and games, and the huge iced cake was cut by our guest of honour and neighbour, Corporal Horace Clarke, RAF, back from service in North Africa. Lighting and music were supplied by Mr Wooton of Richmond Road, and after dark we had fireworks.

IN THE COURTS 1851

Towards the end of August, Frederick Bowen, William Torrifield, Mark Samways, Frederick Boon and John Wellman were brought before the Town Magistrates charged with stealing apples from Mr W. Symes' orchard at Yeovil Marsh, and breaking the windows of Mark Rickett's nearby cottage. The five defendants had been to the Yeovil Marsh Feast, and as they made their way home at about one o'clock in the morning they decided to raid Mr Symes' orchard. Their noisy efforts to knock down the best apples by throwing sticks and stones up into the trees woke Mark Ricketts who, opening his bedroom window, shouted at them to go away. In reply, a barrage of apples and stones were hurled at the cottage, smashing several window panes. The general commotion brought Mr Symes to the scene who, in no uncertain terms, told the culprits to get out of his orchard. The *Western Flying Post* reported that the 'impudent rascals had threatened to murder him'. The outcome – John Wellman, discharged; Frederick Bowman fined four shillings and costs for stealing apples; and Frederick Boon, Mark Samways and William Torrifield each fined four shillings and costs for breaking windows.

In 1851, stealing apples was a serious offence, and only a few days before the previous case was heard, two Yeovil Marsh men – Matthew Hilborne and John Jeffrey – were both sentenced to one month's hard labour for stealing apples from Mr Dibble's orchard.

The Yeovil Petty Sessions, with the County Magistrates on the bench, heard cases from the nearby villages and at the Court held on 3 September a 'Martock Lass' was summonsed by James Pitman, described as 'an old man, toothless and tottering on the brink of the grave', for an assault. The old man told the bench that the woman had hit him 'terrible and he veeled the pain in his stummack'. In her defence the 'Martock Lass' stated that she had been on her way to church when the old man had called out to her to come into his cottage and then 'acted in an indecent manner'. The *Western Flying Post* described the following exchange between W. Hoskins Esq., one of the Magistrates, and the defendant 'Martock Lass':

'Mr H – Are you married?
Defendant – No.
Mr H – How many children have you had?
Defendant – I've got one, Sir.
Mr H – How many have you had?
Defendant – Three, Sir.
Mr H – What, bastard children?
Defendant – Yes, Sir.
Mr H – Then you must not assume much modesty.
Defendant – But if I was wild once, Sir, that is no reason why I should be always; I'm not so bad as to be pulled about by an old man like that, Sir.'

The 'Martock Lass's' brother corroborated his sister's statement, and the case was dismissed.

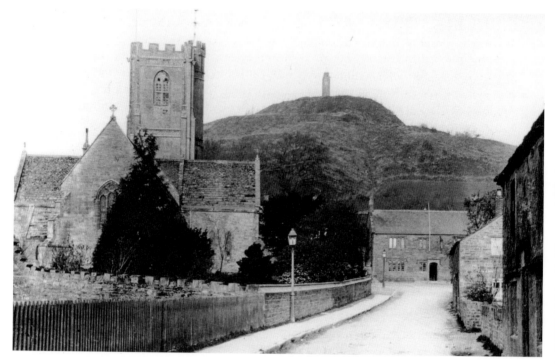

George Stuckey was illegally expelled from the Montacute Friendly Society in 1851.
A photograph of Montacute taken at the end of the nineteenth century.

Another Martock case on 24 September involved James Larcombe, Henry Pope,
George Saunders, Samuel Stickling and William Parsley who were summonsed for
unlawfully assembling in the streets of Martock and interrupting the village Constable
in the execution of his duty. The court was told that the defendants were part of a
large crowd carrying about the effigies of two villagers alleged to have committed a
breach of good morals. When the Constable tried to stop the proceedings, Larcombe
had hit him over the head with a stick and the other four stood accused of aiding and
abetting the assault. James Larcombe and William Parsley were fined ten shillings each
(a week's wages for an agricultural labourer) and the others were dismissed after a
reprimand from the Magistrates.

At the same court, Isaac and Charles Bool, stewards of the Montacute Friendly
Society, were summonsed by George Stuckey for illegally expelling him from the Society.
The bench was informed that George Stuckey had cut his wrist while sharpening his
scythe, but when he applied to the Society for sick pay, the Bools alleged that he had
been drunk at the time, and not only had they refused to pay him, but had fined him
for being under the influence of drink! When George Stuckey refused to pay the fine
within the required time, he was expelled from the Montacute Friendly Society. The
Magistrates ordered George Stuckey to be re-admitted to the Society and the stewards
to pay his costs. The two Bools appeared reluctant to accept the ruling and told the
bench that they believed the Society's members would not re-admit George Stuckey.

The Chairman, Captain Harbin, informed the Bools that 'such obstinacy would not be accepted, and if they would not carryout the Court's instructions, they would be compelled to against their will'. In 1851, a neglectful employee or one who left his work unfinished could be summonsed to appear before the Magistrates. Henry Heffer had been a foreman employed by Yeovil glove manufacturers, Messrs W. Bide & Co., and was summonsed for neglect of duty. The bench was told that Henry Heffer had been entrusted with dressing a quantity of lamb skins, but had left the dressing yard for some unspecified reason, and as a consequence the skins had been damaged. The loss was £30, and Henry Heffer was found guilty, ordered to pay this sum to his former employers, and fined £2 plus costs with imprisonment in default of payment. George Crease of East Coker, was summonsed by Mr Charles Andrews of Trent, for leaving his work unfinished. George had been engaged with three others, to cut a field of wheat, but had left before the work was finished, claiming that Mr Andrews had failed to give them all the cider promised for the job. In reply, Mr Andrews stated that: 'The rascals drank twenty four and a half gallons of cider, and had only cut three acres of wheat'. George Crease responded by claiming that the cider was not good enough because Mr Andrews had sold all his own cider for £2 10s a hogshead (a large barrel containing 52 gallons or 238.7 litres), but had bought their cider in Yeovil. It had not been fit to drink and 'stank from one end of the room to the other'. Mr Andrews, in turn, claimed that he had paid thirty shillings a hogshead for the Yeovil cider and, because he considered it was good enough for him to drink, it was good enough for his workmen! The Magistrates found George Crease guilty and sentenced him to fourteen days in the 'house of correction'.

AUGUST 1948

Surprise, surprise, following a week of brilliant sunshine and high temperatures, it rained on Bank Holiday Monday, 2 August 1948! However, a little rain did not deter many Yeovilians from heading for the coast by road and rail. Over 900 day-trippers left Pen Mill Station for Weymouth on the recently nationalised British Railways and, at Town Station, several hundred more set out for Lyme Regis and Seaton. At the beginning of the Bank Holiday weekend, two special trains departed Pen Mill with some 600 naval personnel from Yeovilton, and over 200 soldiers from Houndstone Camp left Town Station on a special.

The wet Bank Holiday was a bumper day for the town's cinemas. Mr Ernie Brown, the popular manager of the Odeon Cinema, reported that nearly 4,000 people had seen *Oliver Twist* and queues began outside the Gaumont, in the Triangle, for the first performance of *Forever Amber* at half-past ten in the morning.

In the summer of 1948 the Olympic Games were held in Wembley Stadium, and on Friday, 6 August, the *Western Gazette* reported that: 'During the early hours of Monday morning several thousand inhabitants of towns and villages in South Somerset watched the progress of the thirteen athletes, drawn from all parts of the county, who carried the burning Olympic Torch on part of its journey from Wembley Stadium, principle

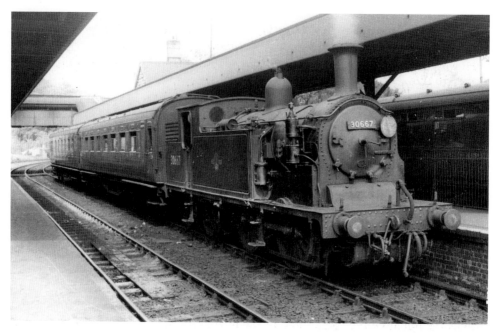

Yeovil Town Station from where several hundred day-trippers left on August Bank Holiday in 1948.

venue for the Games, to Torre Abbey, overlooking Torquay Harbour, where it was used to kindle the flame in preparation for the Olympic yachting contests.

'Each bearer, holding aloft his 2½ lbs metal torch which he could afterwards retain as a memento of the occasion, ran approximately two miles, and the passage from the Dorset-Somerset border to the final hand-over at the Devon boundary was completed within about three hours. Before taking up their various staging positions along the route, the runners were briefed at Yeovil Police Station by Mr W Park of Crewkerne, who, in conjunction with his colleagues from the Central Council for Physical Recreation, was responsible for the Dorset and Somerset relay arrangements. Refreshments were provided by Mrs Clift, of the Chelsea Tea-rooms.

'While waiting at the Toll House, Yeovil Bridge, for the arrival of the torch, R. J. Tutton (Yeovil Athletic Club) signed scores of autographs for the crowd which had gathered. P.C. Hill (Taunton A.C.) who had born the torch down Babylon Hill from the Halfway House, handed over at 1.15 am – ten minutes ahead of schedule. Tutton, whose home is at 18 Glenville Road, Yeovil was paced by friends from Yeovil A.C., through the main streets of the town and up Hendford Hill to the Quick Silver Mail Hotel, where he handed over to E. Aplin (Taunton) amidst the cheering of an even larger crowd.'

In 1948, as now, July and August were the traditional holiday camping months, and twenty senior and twenty-four junior members of St John's Gym enjoyed their second annual camp in fine summer weather at Sandy Bay, Exmouth. A seniors cricket match of 20 overs with the Old Exmouthians resulted in a 48 runs win by the Yeovil team.

The camp sports and parent's visiting day included two, three-legged and wheelbarrel races, and throwing the cricket ball; afterwards the parents were entertained to tea.

However, campers along the West Dorset coast on Saturday night, 7 August, were not so lucky when a violent 55 mile per hour gale roared in! Hundreds of campers in tents were evacuated from the Bridport municipal camp site at West Bay, when the combination of nearly an inch of rain and a high tide in the harbour, caused the adjoining River Brit to overflow its banks. The *Western Gazette* reported that two Belgian boys on a hiking tour lost all their money in the rush to escape the rapidly rising waters.

A cloud burst just before Sunday lunch the next day flooded many of the lower parts of Yeovil. Manhole covers at the bottom of Middle Street were lifted by the force of water, and roads leading down into the town were described as miniature rivers. The storm stopped as suddenly as it had begun, and children were soon out sailing model boats on the flooded Station Road. The electricity supplies failed in the Yeovil Junction area and many Sunday dinners were lost or delayed.

During the Sunday storms, Yeovil Cycling Club braved the weather for a trip to Melksham. Travelling back through the valley of the River Avon, tea was taken in the George Inn at Gurney Slade, and the club returned home via Shepton Mallet and Castle Cary.

On Bank Holiday Monday, 21 Somerset Army Cadets left for a nine day visit to the British Army of the Rhine in northern Germany. The party included two officers and eight cadets from the Yeovil School Corps, Captain H. M. Lyddon, and Second Lieutenant D. Wood, Lance Corporal D. W. Hancock and Cadets R. Salisbury, C. J. Evans, J. K. Jones, S. J. Keevil, J. Hancock, K. David and R. W. Sandrey.

The Band of No. 1032 (Yeovil) Air Training Corps Squadron attended a three-day rally of over 1,500 ATC officers and cadets at RAF Halton, from 5 to 8 August.

On 6 August, the *Western Gazette* reported that at Upway's 'Big Affair' on Bank Holiday Monday, the hounds of the Cattistock Hunt were paraded in the show ring, and the Master, 'acknowledging the warm reception accorded by the crowd, described it "as one of the best arguments against those who contended that there was no further interest in British field sports." He commented: "Our opponents are out to forbid hunting and coursing, and they hope to bring Bill before Parliament in the near future. I appeal to all who are interested in field sports to remember that point-to-points and many other amusements are bound up with our field sports, and that it is essential that all who love the hounds and field sports should organise themselves in defence against the attempts to take away our freedom."'

Bread rationing, introduced for the first time two years before in July 1946, ended on 29 July 1948.

September

SEPTEMBER 1880

At the beginning of September 1880, the Borough Magistrates renewed all the Yeovil beer house licences following the Superintendent of Police reporting that no complaints had been received about their conduct. However, John Channing, manufacturer of soda water and ginger beer of Middle Street, was fined ten shillings plus costs for illegally employing Henry Penny, a youth under eighteen years of age, after 2 p.m. on Saturday 24 July, despite being warned not to do so on numerous occasions by the Factory Inspector.

There were lively scenes in the Magistrates Court when Elizabeth Fozard and Herbert and Elizabeth Payne appeared, charged with creating a disturbance in Mudford Road. Police Sergeant Holwell testified that shortly after midnight on 28 August, in company with PC Dicks, he had gone to Mudford Road where he found the three defendants shouting and swearing at each other, and recalled that 'the women were using disgraceful language'. Herbert Payne had invited the sergeant into his house saying that he would give him something, but before the officer could accept, Payne dashed inside and returned brandishing an iron bar, shouting that: 'He had done two months for one policeman and expressing the pleasure it would afford him to do three for the sergeant'. However, the threat was not carried out and the sergeant managed to diffuse the situation. PC Dicks corroborated his sergeant's evidence. The testimony of the two officers was constantly interrupted by the two Elizabeths who, according to the court reporter, 'persisted in repeating a foul epithet they stated the sergeant used towards them. This allegation was, however, denied. The noise made by the "ladies" rose to such a pitch that more than once the magistrates had to threaten they would hear the case in the defendants' absence'. Mrs Fozard and the Paynes were fined thirteen shillings each, to be paid immediately or in default to go to gaol for fourteen days. At this, Mrs Payne 'Declared her intention, in a ladylike way, to suffer imprisonment rather than pay ... farthing'. The *Western Gazette* did not report the outcome of her threat.

The *Gazette* reported that: 'The effigies of two persons who had, it is presumed, incurred the displeasure of some of their neighbours were carried through Wellington

The effigies of two residents were paraded up Wellington Street and afterwards burnt.

Street on Tuesday night, and afterwards burnt. The noise caused by the tin kettles etc. carried in the procession was deafening'. This form of rough justice called the 'skimmington', 'riding the stang' or similar variations, was often carried out in many parts of the country when someone was considered to have stepped out of line, and in my book *Shocking and Surprising Somerset Stories* I tell of two cases in Yeovil in the 1800s which resulted in people being sent to gaol.

On 3 September 1880 the *Western Gazette* contained a warning to tradesmen that a 'fashionable lady swindler' was working in the towns of Somerset, ordering parcels of goods from shops and then decamping with the proceeds.

On Saturday afternoon, 4 September, John Bragg, a porter employed by the South Western Railway Company, was crossing the line at Town Station when he was knocked down by an excursion train coming from Yeovil Junction. He fell between the two rails of the track, but despite the shock and his injuries he had the presence of mind to lie still and let the train pass over him; to move would have meant certain death. A semi-conscious Mr Bragg was quickly lifted from the track and carried to the station platform where his injuries were found to be a severe blow to the shoulder plus shock. He was then conveyed to Yeovil Hospital on a station trolley. It was suggested that the accident had been caused by an engine in a nearby siding noisily blowing off steam and which had prevented Mr Bragg from hearing the approach of the excursion.

A few days later, Mr J. Penny, a grocer accompanied by a young assistant called Dunford, was driving his pony and trap down South Street when the pony bolted and galloped flat out into Middle Street where the trap overturned. The grocer and his assistant were thrown out and both suffered severe cuts and bruises.

On 2 September, the Yeovil Volunteer Fire Brigade, commanded by Captain Edwards, were in action, but on this occasion it was a practice in front of Newton House involving pumping water from the River Yeo and extending the fire escape with 'satisfactory results'.

The Weslyan Band of Hope held its monthly meeting at the Institution Hall in Church Street on 3 September. Recitations were given by the Misses A. Stroud, Amy Dimond, Alice Rundle and Polly Hitchcock. Mr J. Luffman delivered an interesting and instructive address and the 'proceedings were enlivened by the singing of several temperance songs'. A number of children joined the Band of Hope at the close of the proceedings. On Wednesday 8 September, Yeovil cricketers beat Martock at home. Yeovil's W. N. Roe was bowled out for 6 runs in the first innings, but went on to make 143 in the second; only one Martock player made double figures. The following contribution to the *Western Gazette* appeared on 10 September 1880 and I think gives a flavour of that time over 120 years ago when, in many ways, it seemed to be an age of innocence compared with our own: 'Should any of our readers be addicted to practical joking we would warn them to exercise a little more discretion than was displayed last week by two or three frolicsome Yeovilians just emerging into manhood. They thought they would "have a lark" with some young fellows of their acquaintance and several of the "fairer and gentler sex" and accordingly put their heads together and at length resolved upon what they considered the best plan to adopt to carryout their intention. They concocted epistles couched in the most affectionate language, but all different as regards the wording and hand writing, making an appointment for each of their beautiful and masculine friends to meet "One who dearly loves you" at the cemetery gates at 8.15 p.m. on Sunday. But it did not work exactly, for those to whom they wrote being very confidential towards each other, and perhaps having their suspicions aroused, immediately on their receipt communicated the contents of the *billet-doux* to one another. The upshot of the affair was that none of them repaired to the appointed *rendezvous*, except one young gallant, out of the half dozen or so who had received such delicate attentions. Next time anything of the sort is attempted, care should be taken not to select such bosom companions, or the result, as in the present instance, may be that the laughter is "all on the other side," at the non-accomplishment of the design, and the consequent waste of sundry pence expended in postage stamps and writing materials.'

EXETER CITY RESERVES *v.* YEOVIL SEPTEMBER 1908

On 13 October 1908 'LC' sent a postcard to Mr G. Brown, The Stores, Wyke Regis, Weymouth. The message read: 'Thanks for PC. Will write a letter in the week. Can you see me in this Photo. I went up and seen the Weymouth match. Will tell you about it in the letter. City plays the Saints Wednesday.'

The postcard shows some of the 2,000 spectators at the friendly match between Yeovil Town and Exeter City Reserves on Saturday 26 September 1908 and upon which the *Western Gazette* reported: 'At Exeter on Saturday, before 2,000 spectators,

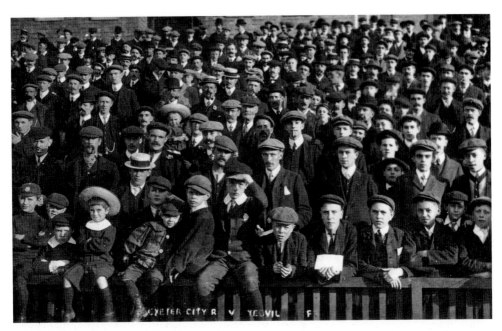

Some of the spectators at the match between Exeter City Reserves and Yeovil in September 1908.

Yeovil were not at full strength, lacking the services of Clarke on the wing, whose place was filled by Harbour, and W. Seymour at centre-half, Spinner filling up this breach. Exeter had a full team out, including no few than five professionals. Immediately after the commencement Sillick received a pass from Johnson and sent on to Mudd, but the latter's shot went wide the Yeovil goal. At the homesters' end Hayward easily defeated the professional and late Everton back, Crelley, and Fenwick, and sent in a swift shot at the Exeter goal which Wells luckily saved. The Exeter right wing then led down a determined rush and but for the fine defence play of Seymour, they would have scored. The "green and whites" afterwards attacked and Wells displayed ability between the sticks, the goalie fencing off repeated shots. Exeter returned, but all efforts to find the net were frustrated, and the visitors breaking away, Barnes sent in a shot. The homesters now had an excellent opportunity to score, and this was well taken care of, Drain putting the leather past Cook. He was offside however, and the appeal was allowed. The visitors' forwards were conspicuous for some good movements, and Lodge had hard lines in not scoring. Wells was defeated, and the ball struck the upright and rolled right across the front of the goal, but there was no forward up to put the finishing touch. After a rush up the field by the Exeter men, Pridham put in a lovely centre which Mudd trapped and put in a shot which quite defeated Cook. Half time: Exeter, 1; Yeovil, *nil.*

'After crossing over, the "green and whites" volleyed a few shots at Wells and then Johnson sent to White who in turn passed to Drain, and the latter netted the ball. The visitors now seemed to fall to pieces and the Exonians exerted themselves to the utmost. Further goals were obtained for them by Drain, Mudd and Johnson.

Result: Exeter 5; Yeovil, *nil*. Teams:- Yeovil – Cook; H. Seymour and Kemp; Cooper, Spinner and Maughan; Barnes, Larcombe, Hayward, Lodge and Harbour. Exeter – Wells; Fenwick and Crelley; Tierney, Johnson, and Letheran; Sillick, Pridham, Mudd, Drain and White. Referee: Sergeant-Major Adams.'

And what happened at the Weymouth match about which 'LC' proposed to write? This was an English Cup match and in which Exeter City, playing at home before a crowd of 5,000 on a brilliant sunny autumn day, destroyed Weymouth 14-*nil*. I think 'LC' had plenty to tell Mr G. Brown.

MODERN WITCHCRAFT

In September 1854, the *Western Flying Post* reported the following curious incident in Ram Park, now Sidney Gardens:

'MODERN WITCHCRAFT. – A singular case of vulgar superstition came to light here last week. Some men were cleaning out the Ram Park pond, and on Thursday last at the bottom of the pond a workman named George Swatridge picked up a pickle-bottle containing figures and signs, which at once stamped it as a device of witchcraft. Three figures of the human body, fashioned out of gutta-percha and some other substance, and stuck all over with black pins, were in the bottle. There was writing at the back denoting that the figures were intended to represent persons named Roan, Mary Millard, (Mrs Roan, to wit) and Trimby, and the artist consigned them to "sudden destruction, legal and moral" &c. The sign of the planet Saturn was made on the breasts of these unfortunates. There was also a flat piece of lead in the bottle, with

Sidney Gardens, shown here in 1900, was laid out on Ram Park.

cyphering and other marks on it, no doubt of great significance, but we don't know what. The men whose effigies were treated in this way are police constables, and have probably in that capacity rendered themselves obnoxious to some one who determined to serve them out with the devil's aid. Roan has for some time been very ill, but has recovered since the finding of the pickle-bottle; which we understand Mrs. R. and some other people think marvellous and not to be laughed at. We must, however, do P.C. Roan himself the justice to say that he assured us – when he brought the apparatus to our sanctum for the further elucidation of its importance which we were unable to give – that he did not consider himself to have been in such jeopardy on its account.'

Nearly seventeen years later in June 1871, labourer William Hyam was brought before the Wincanton Magistrates, charged with stabbing Ann Green, who told the bench that on the evening of 7 June, she had called at Mrs Vigar's shop in Bruton to purchase a candle. At Mrs Vigar's invitation she had gone into the kitchen, but shortly after William Hyam had come into the shop asking who was in there. When Mrs Vigar had said no-one in particular, he pushed past her and opened the kitchen door. Ann Green stated that the prisoner had shouted, 'Hello, is that thee you bitch!' and, rushing into the room, stabbed her twice in the shoulder with a clasp knife. Crying out in pain and pleading that she had done him no harm William Hyam suddenly calmed down and after saying he was so sorry, 'offered her 5s. "to make it up".'

The blood-soaked dress and under-garments worn by Ann Green were produced and the prisoner was asked why he had attacked the woman. William Hyam told the bench that Ann Green had 'overlooked' him with a spell and he had heard people say that 'if you can draw blood that will stop it'. The Chairman of the bench enquired whether he had found any relief since the stabbing but the prisoner replied 'No Sir'.

Mrs Vigar gave evidence and corroborated Ann Green's testimony and PC Parsons stated that when he took William Hyam into custody, he said that he had carried out the stabbing because 'she had overlooked him'.

The prisoner's mother told the bench that during the previous fortnight her son was constantly muttering that Mrs Green was overlooking him and the spell was killing him. Police Superintendent Shepherd stated that he understood William Hyam had injured his head in an accident a little while ago.

All the evidence had now been presented and the Magistrates told the prisoner that had they believed he had been in his right mind when he committed the offence, they would have inflicted a very severe sentence. However, they remanded William Hyam in custody for a week to find if any Bruton householder would be willing to stand surety for his future good behaviour, failing which he would be sent to prison for three week's hard labour.

I have not discovered whether the surety was found or whether William Hyam went to gaol.

On 7 July the *Western Gazette* wrote that the Wincanton case had: 'Furnished a text for comments on Somersetshire Superstition to every journalist between Land's End and John o' Groats,' and quoted from the *Birmingham Daily Mail*:

'Everybody who is acquainted with Somersetshire knows that it is one of the most benighted counties in England. Ignorance rides rampant there, and one has only to

study the Assize calendars to show that it is ignorance of the most debasing kind. As one of the accompaniments of a crass and widespread ignorance, superstition exists to a great extent. A belief in witches, and "evil eyes" and spells, and all such nonsense is more common in some villages in Somersetshire than the belief in a Deity, or a Saviour, or a heaven or a hell. We state these facts from a familiar acquaintance with the locality. Horse-shoes nailed to the door to keep away witches are the rule and not the exception. We frequently have to record instances of gross superstition in Somersetshire; and now we have to add another case to the long black list.'

SEPTEMBER 1918

By the first week of September 1918, the First Word War had lasted four years and one month, but the stalemate of the terrible trench warfare of those years on the Western Front had finally been broken; in August 1918 the Allied Armies had begun the advance which would lead to the end of hostilities two months later on 11 November.

At 5.33 in the morning of Tuesday 3 September 1918, following a three minute artillery and machine gun barrage, 'A' and 'B' Companies of the 2nd Battalion, the Wiltshire Regiment, attacked German positions north-west of the village of Neuve-Chapelle some fifteen kilometres from Lille in northern France. The regimental history records that the attack progressed according to the programme, the Germans were taken completely by surprise, and the final objective of the crossroads known as 'Rouge Croix' was reached. Casualties were said to have been relatively small; six men were killed and eighteen wounded. One of the men of 'A' Company attacking the position was my father, who had served with the battalion since the previous April. The Commanding Officer of the 2nd Battalion was Lieutenant Colonel, Lord Thynne DSO, MP, who would be killed instantly eleven days later on 14 September.

Meanwhile, back in Yeovil, in common with many other families across the nation, my grandparents were trying to carry on as normal, but with constant dread in the back of their minds of the news that their only son would not be coming home. They did receive a telegram several weeks later, but this was to say that he had been wounded and was in hospital.

On 6 September, the *Western Gazette* in its column 'Yeovil and the War' wrote that: 'Lance-Corporal E. B. Way, of the Dorset Regt., whose wife lives at 118 Goldcroft, has been killed in action in France. He was 30 years of age, and had joined up on July 20th 1916, and was drafted to France in November of the same year. For 13 years he was engaged in the piano and music warehouse of Messrs Godfrey and Co., the Triangle, and was very well known. Mrs Way received notification from the Record Office that her husband was wounded, but later received a letter from a chaplain to a Canadian unit to the effect that Lance-Corporal Way had been killed in the recent advance, and that his body had been buried in a wheat field behind the present front line. The chaplain added that he had apparently been killed by a machine gun bullet whilst gallantly advancing on the battlefield, and that death had been evidently been instantaneous.'

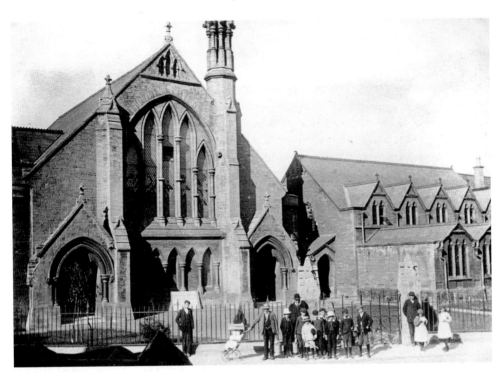

The Revd Edward Brentall MA opened his ministry of the Yeovil Wesleyan church in the Vicarage Street Methodist church, shown here in the early 1900s.

The *Gazette* also reported that: 'Private F. Peaty, R.M.L.I., who will be remembered in Yeovil as a prominent footballer of a few seasons back, is again wounded, and is in hospital in Stoke-on-Trent, suffering from wounds to his left fore-arm. Private Peaty, whose wife lives in St Michael's Road, was wounded a few months ago, but was then treated in hospital in France and sent back to the front line.

'Mr C Dade of 10 South Western Terrace, Yeovil, has received news that his grandson, Private C Samways, West Somerset Yeomanry, attached to the Somerset Light Infantry, has been wounded in the head during the recent fighting in France. The news came in letters in which Private Samways states that his steel helmet was the means of saving his life. He says that his wound is slight and he is in hospital in Warrington in Lancashire. His letters are written in a very cheerful strain and Private Samways expresses a hope that he will be soon home again.'

Mrs Bell of 22 Everton Road told the *Western Gazette* that she had received a postcard dated 23 June from her husband George, the former Boots at the Mermaid Hotel, who had been serving with Worcester Regiment and was now a prisoner of war in Germany. George stated that he was in the best of health, but that being a prisoner of war was not very nice, they were short of cigarettes and tobacco, and it was 'not like home.'

Meanwhile, on the home front, the *Gazette* reported that the regular ambulance train had arrived at Sherborne on 6 September, and thirty-six wounded and gassed

men straight from the front line were removed and taken to several local hospitals. Seven cases were brought to Yeovil, three being taken to the Red Cross Hospital in the Newnam Memorial Hall in South Street and the remaining four to the District Hospital. On the day before, seventeen wounded soldiers recovering in the Red Cross Hospital were entertained at a picnic given by the staff of Wests, the outfitters and milliners shop in Middle Street. A Variety Concert in aid of the Red Cross was given to a large audience in the Assembly Rooms by 'the well-known troupe of pierrots under the management of Mr. Libbis N Burch of Chard.' The shows presented by this amateur concert party were very popular in the area and with its programme of songs, humour and dance, raised many hundreds of pounds for the Red Cross.

The Revd Edward Brentall, MA, opened his ministry of the Yeovil Wesleyan Circuit, with a service in the Vicarage Street Methodist Church, and was later welcomed at a united evening service of the town's free churches.

Yeovil Gloves featured in a large display at the Glasgow British Industries Fair, which was reported to 'have fully demonstrated the ability of English manufacturers to produce an article to suit every taste and requirement.' The enforcement of Government regulations relating to the registration of aliens could cause problems. Early in September, a citizen of the United States of America, Mr O. Frick, an engineer, and his British born artist wife, appeared before the Magistrates charged with failing to register at the Yeovil police station as aliens under the Defence of the Realm Regulations, when they arrived in the town in the previous March. Mr Frick had been employed in the Aeronautical Department of Westland Aircraft and had worked for the War Office since the beginning of the war in 1914. Mr Frick's solicitor told the bench that his client had informed Westlands of his nationality and having so notified all the authorities for whom he had previously worked, he did not realise that he had to register with the local police as well. Accepting that this had been an unintentional oversight, the Magistrates dismissed the case.

Shortage of labour had several times postponed the washing of the medium of the filter beds at the town sewage works, and at their September meeting the Borough Council decided to seek the employment of German prisoners of war for this task.

On 6 September 1918, the *Western Gazette* reported that Battery Sergeant Major W. Brice, Royal Garrison Artillery, of Yeovil, had been awarded the Distinguished Conduct Medal for 'conspicuous gallantry and devotion to duty during recent operations.'

October

Readers of the *Western Gazette* in the first week of October 1870 may well have marvelled at the adventure of young Richard Dell of Cannington, near Bridgwater, who, 'on Wednesday morning last got up from his bed whilst asleep, put on his boots, trousers and hat, wrapped a blanket around his shoulders, and walked off to Kingston, near Taunton. He arrived near the Swan Inn, Kingston, soon after four o'clock in the morning. When he was awakened, he walked home again, by way of Asholt, after partaking of refreshments.'

Meanwhile, back in Yeovil, the Borough Magistrates found Thomas Pipe, of no fixed abode, guilty of sleeping in Mr Joseph Penny's outhouse near Noble's Nap, and committed him to gaol for three weeks. A young tramp was also sent down for three weeks for breaking Messrs Hancock & Co.'s shop window. However, the verdict may have been welcomed by the culprit who said that he 'did it because the police would not give him an order for a night's lodgings.'

Seeking to cheat the Revenue seems to be as old as time and a local mail contractor was prosecuted by the Supervisor of Excise for keeping eight horses whereas he only had licences for six. Mr H. Barfoot, the local Inland Revenue Officer, gave evidence to prove that the defendant had nine horses on 14 May 1870, although he had only taken out licences for six. Mr Brown, a butcher, and Mr Willis, a farmer, said that they had each lent the defendant a horse at the time referred to. However, the Magistrates stated that they were not satisfied with the evidence put forward by the defence that the additional horses were borrowed. They went on to say that they had good reason to believe that the revenue was defrauded in this matter and they were determined to put a stop to this. However, the bench decided to reduce the penalty from £20 to £10 in this case, but in future the full penalty would be imposed.

Foot and mouth was rampant in early October 1870, and the *Western Gazette* reported that new outbreaks had occurred on twenty-two more farms in the district, bringing the total affected places to 800 in the Yeovil area! Several local farmers were

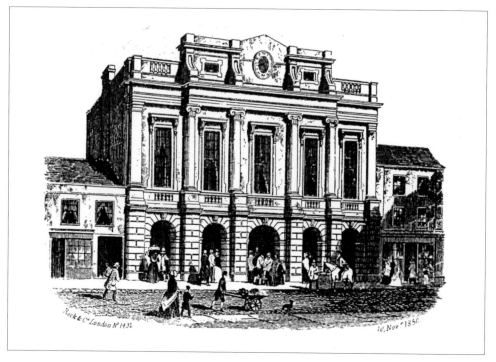

On 12 October 1870, 240 people celebrated the anniversary of the South Street Baptist Chapel in the Town Hall, shown here in an old print.

prosecuted for moving animals from an infected place. The *Gazette* reported that an East Coker farmer and his young pig keeper were charged with allowing fifteen pigs onto the public highway to pick acorns on 4 September. When asked by the Magistrates who sent him out with the pigs, the youngster replied 'Master'. Despite his denial, the farmer was fined ten shillings, but the case against the boy was dismissed. A Mudford farmer was fined ten shillings for receiving forty cows from an infected district.

On Saturday 1 October, a large number of sailors going on leave from the Channel Fleet arrived at Pen Mill Station by train from Weymouth, hoping to connect with various stations on the London and South Western railway. However, when they were told that all the trains had stopped running until the next morning – 'They made use of most violent language and numerous threats towards the railway officials. After acting in the most excited manner for a considerable time, they were persuaded to take beds in various inns in the town and most of them went on their way rejoicing on Sunday morning. Two fine vessels in front of the residence of Mr C Pittard, Townsend, were upset and broken during the night, probably by the excited tars.'

The Mutual Improvement Society held their first winter entertainment in the Town Hall on Tuesday evening, 4 October, with songs, instrumental pieces, poems and readings. Mr Stokes, of Sherborne, was in great demand – his song 'Have faith in one another' was encored several times, and his rendering of 'It is better to laugh than cry' was loudly applauded. Later in the evening, Mr Stokes was again on stage singing 'Her

bright smile haunts me still', followed by applause and demands for an encore. The *Western Gazette* reported that – 'As he had been on the platform three times and as he was slightly hoarse, Mr Stokes did not readily respond to the calls and the President endeavoured to obtain a hearing. The attempt was made in vain, however, and the audience would not listen until Mr Stokes re-appeared. He then sang "I will stand by my friend" and the applause with which this was greeted, was, we hope, ample compensation for the unreasonableness of the demand.'

On 12 October, the Baptist Chapel in South Street celebrated its anniversary with a public tea in the Town Hall attended by some 240 people and, in the evening, the Revd Dr Brock of Bloomsbury preached a sermon to a very large congregation from the words 'Heaven and earth shall pass away, but my word shall not pass away'.

There was a good muster of the Yeovil Company of the 16th Somerset Rifle Volunteers for their monthly inspection by Captain Puard, the 16th's adjutant. It was announced that winter drills would begin on 24 October in the Corn Exchange, and Lieutenant Harbin was attending the 'School of Instruction for Volunteer Officers' in London.

Finally, Madam Colmer, MD (USA), of the Gilead House Dispensary in Middle Street, in advertising her various remedies in the *Western Gazette*, included a testimonial by Monsieur Leys, Surgeon Dentist of Thomas Street, Weymouth, concerning the effectiveness of Colmer's Infallible Worm Medicine. He wrote that all treatments he had tried previous to taking Colmer's Infallible Worm Medicine had not been successful, but after the first dose of the medicine on 19 November 1867 – 'In less than 2 hours its wonderful effects were shown by my passing three monstrous Tape-worms of enormous length with heads attached. The shortest of them was nearly 100 feet in length.'

Incidentally, Mons. Leys, Dentist and Manufacturer of Artificial Teeth, attended every Friday to extract, fill and make artificial teeth, at 'Mr Scott's Seed Stores, Yeovil (side-entrance) 12 till 6pm'.

A TRAGEDY ON THE RIVER YEO

During the evening of Thursday 17 October 1844, James Harris, bailiff to Mr George Harbin of Newton House, fell in the River Yeo near the weir below Wyndham Hill, and John Cridland tried to save him; tragically both drowned.

The *Western Flying Post* reported that Mr Caines, the coroner, held the inquest on the bodies of the two men in the Pen Mill Hotel on the following Saturday, and the first witness to give evidence was Mr George Harbin who testified that: 'On Thursday last men to the number of twenty were employed in emptying the water of the weir pool of the river Yeo near Pen Mill and to carry out repairs to the weir; there were several volunteers, and work was proceeding with great energy. They began about ten and at about half past five, being present myself, I desired the men to cease from work, and partake of some refreshment that had been provided for them in a tent near where they had been working. All the men at the time appeared to be sober – they had had

In October 1844, this weir on the River Yeo was being repaired when James Harris and his would-be rescuer John Cridland drowned nearby.

sufficient liquor, but did not appear to be in a state of intoxication. Harris, as my bailiff, had been looking on as a spectator, and he had nothing to do with the work. Between three and four I desired him to go the Brewery and purchase some beer for the men, and it seems that at the Brewery he had two small glasses of beer given to him. At half past five I desired the men to desist, upon which they had all said they had better finish their job that night, I was however anxious that they should cease, as it was getting late, and the men, in obedience to my directions got out of the water and went to the tent. I saw Cridland at the time, and he observed to me that I had better have the fish taken out of the pool that night, showing by this remark that he was perfectly aware of what he was doing. I took the precaution of asking George Bradley to preserve order amongst the men during the absence of my servant James Meech, but wrangling and dispute took place after they had had their first cup of liquor, and there was rather an inclination to fight. My servant went to the tent and said no more liquor would be drawn that night if they kept quarrelling upon which they agreed to shake hands and make it up. About quarter past seven, when I was at my dinner table, my servant rushed into the room calling out "Dear Sir – something dreadful has happened, for God's sake come, two men are drowned. The boat, the boat!" I ran as quick as I could, got into the boat and took my servant with me, and rowed from Newton to the spot in about ten minutes. Some men were trying to get up the bodies with a crook when we got to the spot; my servant, took the crook, and in about five minutes brought up the body of George Cridland. I directed them to take the body immediately to Pen Mill, the nearest place, to wrap it in blankets, and get immediate medical assistance. This was done, and we continued our search; from five to ten minutes elapsed and then my servant, James

Meech, succeeded in bringing to the surface the body of poor Harris. With the aid of those present we brought the body down to the mill, where I ascertained that they had placed the other body in the hay-loft; I had it brought down immediately, and both bodies taken into the kitchen of the mill, whilst a fire was lit in the bake-house. Before the surgeon came every effort was made to restore animation, but our endeavours were useless; I should think they had been more than half an hour in the water. Harris was not addicted to liquor and the whole time he was in my employ for six years I never saw him intoxicated.'

The next to give evidence was George Bradley, a dairyman, who told the inquest that he had been placed in charge of the work in the absence of James Meech, Mr Harbin's servant. The men had drunk about two cups of beer each, but he did not think they were drunk. James Harris, the bailiff, had drunk a little quantity of beer but was perfectly in control of his senses. The witness stated that he had seen the bailiff some ten minutes before he heard a splash from the river above the weir.

Carpenter Hugh Slade testified that at about seven he had been walking along the footpath on the opposite bank of the river and had heard shouting and arguing coming from the tent. He had stopped to listen, and in the moonlight he saw James Harris come out of the tent and walk straight into the river. Seeing the bailiff struggling in the water, Hugh Slade stated that he had shouted for help and men had come running from the tent. The carpenter described how John Cridland had run to the river and 'without taking off even his hat, jumped in. He took the other man by the back, and pulled him back towards the bank; neither of them spoke and they both went to the bottom.'

Recalled by the coroner, Mr Harbin explained that James Harris had 'an affliction of the eyes for which he was surgically attended, and no doubt he had mistook his path and slipped into the river.' Mr Harbin felt it was a pity the men had apparently forgotten that there were ropes and a pole near at hand, but had run instead to his house for the boat.

The coroner stated that he considered there was no need to call any further witnesses because it was quite evident how the two men had died, and as there was no evidence of intoxication. The inquest jury returned a verdict of accidental death in the case of James Harris, and John Cridland had perished in the attempt to rescue him.

Subscriptions were raised to help the families of the two men – James Harris left a wife and five grown up children and the younger man, John Cridland, left a widow and two small children in Bradford Abbas.

THE BOMBING OF YEOVIL OCTOBER 1940

Monday 7 October 1940 was the 401st day of the Second World War and, at 3.45 p.m., the air raid sirens wailed their warning over Yeovil. Townspeople hurried to take shelter and, some ten minutes later, over twenty German Ju 88 bombers approached the town from the east – Yeovil was now in the front line.

One week before, on 30 September, a force of German bombers had set out to attack the Westland Aircraft Works, but heavy clouds covered the town and bombing blind

Yeovil Fire Brigade and Auxiliary Fire Service in 1940.

the aircraft released their deadly loads over Sherborne, killing eighteen and injuring over thirty townspeople.

To neighbouring Yeovil it was only a matter of time before the Luftwaffe came back – and they did at about five minutes to four in the afternoon of the 401st day of the war. During the next few minutes high explosive and oil fire bombs rained destruction across the town centre and nearby residential areas. A direct hit demolished the air raid shelter in the Vicarage Street Methodist Church killing four housewives and injuring several of the thirty or so people who had taken refuge in the building. A man, two women and an eighteen-month-old toddler were trapped for a while in a cavity formed by fallen blocks of masonry, but were released relatively unharmed.

In Middle Street a bomb exploded between Montague Burton's shop and Woolworths, killing eight people, including two young men who had been playing billiards in the Saloon above Burton's. Miraculously, most of the 200 people sheltering in Woolworths escaped injury.

The fall of bombs across the town centre damaged shops and business premises, but thankfully with no further fatalities. The *Western Gazette* reported that a young chemist's assistant experienced his second bombing within a week, having transferred to Yeovil from a shop in another town damaged in a raid. Ricketts' glove factory in Addlewell Lane was badly damaged but, once again, mercifully without serious casualties.

Bombs, including an oil bomb, fell on the Higher Kingston Estate and a house in Roping Road was demolished. However, the bombs which fell on the western parts of

Yeovil caused further deaths and injuries. Baker's roundsman, Cyril Rendell from West Coker, was killed in Summerleaze Park where he was delivering bread, a direct hit on an air raid shelter in Grove Avenue killed the two occupants and a housewife died when her house in St Andrew's Road was blown apart. An oil bomb bounced down Grove Avenue, and there was a large crater left in a vacant piece of land opposite the entrance to West Park; craters also pitted the playing fields around Summerleaze Park School. Several houses in St Andrew's Road still bear shrapnel marks from the bombs which fell nearby. There was an unexploded bomb at the junction of Preston and St Andrew's Roads, another in Park Street, and a third in the field near the balloon barrage site at Larkhill; an oil bomb which fell in Everton Road did not explode.

The *Western Gazette* reported that two insurance agents had a 'narrow escape when an oil bomb fell three feet away from the front door of one of a row of houses. It blew in the door behind which they were sheltering at the invitation of an evacuee from London, who was the only other person in the house. They were all three thrown to the floor, the door falling on top of them. Splinters from a bomb went straight through the rear of the car the men had left outside, and another large piece through the roof and landed on the driver's seat. Oily mud thickly bespattered the car. Luckily the bomb did not ignite although the force of the explosion was sufficient to break the concrete doorstep and tear laths from the wooden shed at the rear of the house.'

The bombers were gone in minutes and when the 'all clear' sounded an hour later, sixteen people were dead and twenty-nine injured, of whom nine were seriously injured; no bombs hit the Westland Works.

The Luftwaffe came again the next evening, and between ten past seven, when the sirens wailed the alert, until the 'all clear' forty five minutes later, some forty-four high explosive bombs were scattered over the western part of Yeovil. This time Preston Grove and Westbourne Grove bore the brunt of the attack and once again the Westland Works remained unscathed. The raid left eleven dead; all were killed when an air raid shelter at the corner of Westbourne Grove and Preston Grove was totally destroyed by a direct hit. Eight of those who died, including two children, were soon identified, but early the following morning an unidentifiable adult body was found in the St Andrew's Road cul-de-sac, followed shortly after by that of a badly mutilated child in a garden in Preston Grove; five days later, a mutilated female corpse was found on allotments by the Westland airfield. Despite extensive enquiries, the three bodies were never identified, and they were buried in Yeovil cemetery where a headstone marks their last resting place.

The third attack on Yeovil came on Saturday evening 12 October, when a lone bomber dropped five high explosive bombs on the town centre. Part of Church House, occupied by the solicitors, Messrs Batten & Co., was demolished, and the south windows in St John's church were damaged. The *Western Gazette* reported that the glass canopy over the entrance to 'a picture theatre was shattered and some tiles dislodged but that was the extent of the damage. No-one in the cinema was hurt and the show went on.' This was the Central Cinema in Church Street, but war time censorship forbade the naming of towns, streets etc., in newspaper reports of air raids. The film showing at the time was *Jack's the Boy* starring Jack Hulbert and Cicely Courtneidge. The other

bombs fell in Park Street and at the back of a house in Pen Hill demolishing part of the building and damaging the adjoining South Street Infants School; there were five reported injuries in the town. Houndstone Camp was bombed on 12 October when five soldiers were killed and thirty-two other personnel were injured, and again on the 14th, when thirteen died.

The fourth raid on the town came on 16 October when bombs fell in Mudford Road, destroying five houses and injuring three occupants of No. 122. Although this would be the last attack on Yeovil in 1940, the air raid warnings would be given on another twenty-eight occasions before the end of the year, as the Luftwaffe passed overhead to bomb Bristol and South Wales.

In the four raids on Yeovil in 1940, twenty-seven premises were totally destroyed and over 800 damaged, but the target, the Westland Works, was unscathed.

OCTOBER 1952

On Tuesday 7 October 1952, Mrs Mary Ann Troke celebrated her 105th birthday at the home of her son-in-law and daughter, Mr and Mrs R. J. Toms of 27 Penn Hill. Mrs Troke had been born Mary Ann Pudden at Skinner's Hill, East Coker, in 1847, where, the *Western Gazette* wrote – 'her father and brother were well known carpenters during the last century and were considered two of the best craftsmen in the area. They were responsible for much of the maintenance and repair work at East Coker Church and Montacute House in those days.' The *Gazette* went on to relate how, during the last war, Mrs Troke had been staying in Welling, Kent, where she lost all her belongings when the house in which she was living was destroyed by a German bomb. Mrs Troke was said to have led an active life until her 102nd birthday, and attributed her great age to 'hard work alone being the secret of long life'.

During the first week of October 1952, eighty-seven-year-old Mr Joseph Arnold, described by the *Western Gazette* as Yeovil's oldest tradesman, retired after over fifty-five years in business as a barber and tobacconist in Middle Street. He recalled the many changes he had seen in the trade and the 'remarkable changes in prices when many years ago cigarettes could be bought for five a penny and best tobacco was only three pence an ounce. Cigars, now priced at about 1s 5d each, were on sale for twopence'.

Alderman Wreford Pittard retired after twenty years as a Yeovil Magistrate and Chairman of the bench for the past two years. At Alderman Pittard's last court, a driver appeared before the bench, summonsed for causing an obstruction with his car in Stars Lane. In his defence, the driver claimed that another car had been parked opposite his vehicle after he had left it. The *Western Gazette* reported that: 'Addressing the Chairman (Ald W.J.C. Pittard), who was retiring from the Bench, the defendant said "You are making your last appearance after 20 years and this is my first appearance in court, I hope you will be as easy as you can." Defendant was given an absolute discharge but ordered to pay 4s costs.'

A soldier from the Royal Army Service Corps Training Battalion at Houndstone Camp

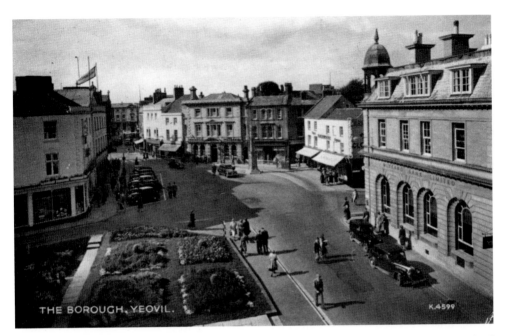

THE BOROUGH, YEOVIL. K.4599

A view of the Borough in the early 1950s, note the garden laid out on the site of Boot's Medical Hall, destroyed by a German bomb in April 1941.

was brought before the Somerset Quarter Sessions at Wells, charged with various offences including theft and breaking and entering at the camp. The court was told that the soldier had escaped from the guardroom where he was awaiting transport to a military prison, and had hidden for eight days under one of the camp buildings, during which time he had committed the offences. The prisoner had finally been found when a police officer had crawled underneath the building, and was captured in a 'dirty, unshaven and subdued condition'. Following the sentence of one year's imprisonment, it was revealed that the prisoner had a number of previous convictions and was under sentence of 142 days' detention imposed by a District Court Martial, none of which had yet been served.

Members of the Yeovil Cycling Club enjoyed a Sunday run to the Quantock and Brendon Hills, returning by way of Milverton, Taunton and Hatch Beauchamp. Phew! And I could only manage West Bay – once!

Entertainment of a more sedentary nature during the first week of October fifty years ago could be had at the Odeon Cinema where Jack Hawkins, Michael Denison and Dulce Grey were starring in *Angels One Five*, the story of a fighter squadron in the Second World War. At the Gaumont, Jack Hawkins was starring with Phyllis Calvert in *Mandy*, about a little girl born deaf and the effect on her parents. The second feature was the classic comedy *Passport to Pimlico*. In the Central Cinema, Doris Day and Gordon MacRae were appearing in the musical *On Moonlight Bay* – the only film being shown in colour in the town's cinemas that week.

There was live theatre at the Princes Theatre in Princes Street, with the Roc Players presentation of *Black Chiffon*, a family drama described as 'Lesley Storm's Outstanding

Success and One of the Best Plays Offered to British Theatre Goers since the War'.

The *Western Gazette* reported that – 'Miss Ffangcon Davies (business manager of the Roc Players) deputised for the Manager, Mr Timothy Johnston, and gave an interesting talk on the "Theatre" at Tuesday's meeting of the Holy Trinity Parish Fellowship. The speaker dealt with theatre in the provinces, its wide scope and its many problems. She stressed the influence of the theatre on the morale of the nation.'

Dr J. Barlow gave his impression of life in America to Yeovil Rotarians, following his two months holiday earlier in the year. The *Western Gazette* wrote that the Doctor recalled arriving in Boston by night and – 'The amazing display of neon lighting from most of the buildings in the city centre. During his stay in America Dr. Barlow spoke to a group of students at Yale University on the National Health Scheme, as it concerned a general practitioner, and his audience seemed most interested. They had been particularly interested in how a doctor was supposed to look after 4,000 patients single handed. Concluding Dr. Barlow said, "The Americans have everything you have ever thought about and some of the things you have never considered. They have every labour-saving device. Every family has a motor car, a television set and a wireless, but they are still not any happier than we in England."'

And finally, the chart toppers of October 1952:

Glow Worm	Mills Brothers
It's in the Book (Parts 1 and 2)	Johnny Stanley

November

Looking back from the vantage point of one hundred and forty five years, 1861 could be said to be one of those years which had a profound effect on the world in which we live. Thomas Sutton produced the first ever colour photograph; Frenchman Germain Sommelier invented the compressed air power drill; Louis Pasteur published a paper proposing that germs caused disease; Romania was created by the unification of Moldavia and Wallachia, and Russian Czar Alexander II abolished serfdom. In France, Pierre Michaux added pedals and a crankshaft to a 'hobby horse' and created the 'velocipede', the first popular bicycle; Italy was unified under King Victor Emmanuel, and Mrs Beeton published *The Book of Household Management*. Across the Atlantic, Abraham Lincoln was inaugurated as the sixteenth President of the United States of America; seven southern states seceded from the Union to form the Confederate States of America, and on 9 April 1861 the Civil War broke out between the Union and Confederate States. Four bitter years later and with nearly a million dead, the Confederate States surrendered and the United States remained united.

In December 1861, Prince Albert died at the early age of forty-two and the widowed Queen Victoria entered a long period of mourning.

However, during 1861, Yeovilians continued with their daily lives little affected, it seems, by these momentous events. In the first week of November the usual crop of misdemeanours were set before the Town Magistrates; there were four disorderly drunks, three men and one woman; the landlord of the White Hart was fined ten shillings plus costs for selling beer during prohibited hours; there was one case of assault, and a failure to pay maintenance. A High Street draper was summonsed for obstructing the pavement with a box, and another shopkeeper was summonsed for leaving a bedstead outside his premises. However, both cases were dismissed as the defendants proved they were not to blame.

Guy Fawkes Night was not popular with the editor of the *Western Flying Post*, who wrote: 'There seems to be a certain class of the population determined to perpetuate

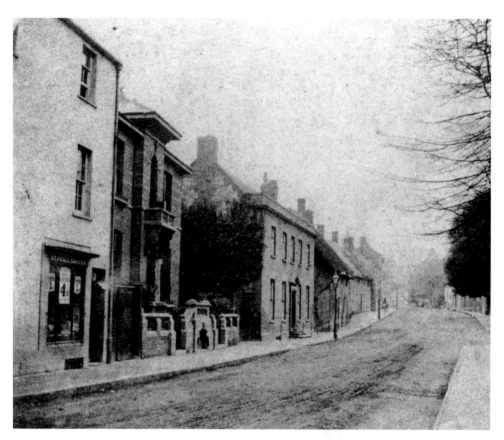

Kingston looking north, c. 1870, where complaints were made about the state of the pavement.

the remembrance of the odious Popish Plot by an annual conflagration. The authorities are as determined, and wisely in our opinion, to put a stop to such exhibitions within the limits of boroughs. In carrying out the provisions of the Act last Tuesday, the police were rather rudely handled, but they succeeded in discharging their duty in a manner which will probably put an end to such pyrotechnics next year.' However, the Editor had some cause for concern, because on 5 November a hayrick at Hollands was set on fire, allegedly by bonfire revellers.

Mrs Dauncey, of Yeovil Marsh, accompanied by her son and his friend, was driving her horse and trap into Yeovil, but as they passed the Nurseries in Preston Road, the horse shied and then bolted. All the passengers were thrown from the trap, which was smashed to pieces as the frightened animal galloped along Preston Road. The runaway was finally stopped at the turnpike in Kingston and, apart from shock and bruising, Mrs Dauncey and her young passengers were none the worse for the experience.

Repairs to a pavement resulted in a trap, belonging to Mr Warren of Marston Magna, being driven into the shop window of Mr Scott, the seedsman, breaking three panes of glass and damaging goods on display. This accident and the state of the town pavements no doubt caused the Editor of the *Western Flying Post* to comment: 'The

correspondent of a Dorchester newspaper compliments us on the improved state of our highways. We would merely request him to put on his best hat and walk for a quarter of an hour up and down the pavement opposite the Red Lion in Kingston after a shower. We believe it to be the duty of the Inspector to put a stop to this nuisance which passengers in that locality are too well acquainted with'.

On 7 November, Mr Senior delivered a lecture in the Mechanics' Institution on 'Charles Dickens, a Reformer of Abuses' which the *Flying Post* praised, and wrote: 'As a plain lecture on a homely subject it was excellent, and Mr Senior is a lecturer whom we shall be glad to see again in Yeovil. Mr Senior understands his business'. However, the paper was not so impressed with a lecture on John Wesley, the founder of Methodism, given before a small audience in the Institution by a Mr Applebee, who was '… a young man who wears Byronic collars and whose general appearance and language would induce the notion that he delights in rolling not only his eyes but his imagination in "fine frenzy" – in endeavouring to render palatable a history that must have been familiar to everyone of his hearers, wandered into a painful extravagance of verbiage – in fact it was not the sort of lecture that is wanted. A simple discourse upon "things not generally known" would have proved a much more acceptable entertainment, than the politico-religious rhetoric of Mr Applebee'. The Yeovil Literary Society began their winter programme with a vocal and instrumental concert conducted by Mr Loaring in the Town Hall, and the performances were reported to have been 'creditable and one or two were honoured with an encore'. However, the correspondent went on to write that 'We should be glad to see more female vocalists in future concerts'. Squire Neal of Yew Tree Close entertained over 100 of his workpeople and their families to a Harvest Home supper of 'good old English fare of roast beef and plum pudding'. In response to the toast to the squire and his lady, Mr Neal told the gathering that: 'It was his sole and earnest wish to make them all comfortable and happy, at the same time he would urge of them the necessity of being attentive to their work and that by so doing, would not only make themselves comfortable and happy, but would gain the esteem and respect of those set over them'. The ninth of November 1861 was Mayor making in Yeovil, and the Council assembled in the Town Hall to elect the Mayor for the next twelve months. The retiring Mayor, Alderman William Bide, was unanimously re-elected for a further term of office despite some reluctance on his part following the refusal of three councillors to accept nomination. Alderman Bide was Yeovil's third Mayor following the formation of the Borough Council in 1854 – he served four terms – 1856/7, 1857/8, 1860/1, and 1861/2.

FROM THE FILES

Some articles from the files of the *Western Gazette*.

Not only in recent years can shopping and car parking in Yeovil generate heated letters to the Editor of the *Western Gazette*, but in November 1934 a Major from Norton-sub-Hamdon wrote:

'I wonder if the tradesmen in Yeovil realise how much trade and business must be lost to them by the difficulties which country shoppers come up against when they try to shop by

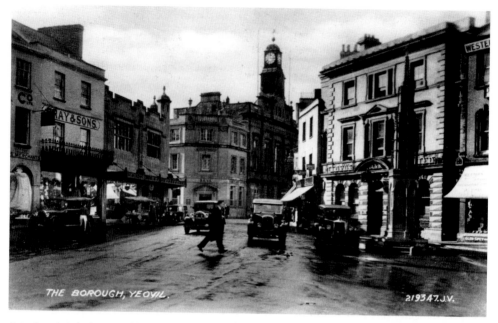

A pedestrian dodges cars in the Borough on a wet day in the early 1930s.

car? At a tennis party a few weeks ago some of us were discussing this matter, and several said that, much as they liked the Yeovil shops, they usually shopped elsewhere on account of these difficulties. A country shopper usually makes a good many purchases, and finds it most inconvenient to have to make repeated journeys to and fro from garage or parking place. Moreover, they resent having to pay to put up their car. Taunton is often a very busy town, with crowded streets, but the motorist is not harassed there. I can understand not being allowed to stay for a long period in a crowded and narrow main street, but what can be the objection to parking for twenty minutes or so round the corner up a side street? To-day I was, in a very nice way, warned by a constable because my car had been eight minutes outside a shop. My own idea was that it was five minutes only, but, in any case, I had rushed my purchases and came away without all I wanted. My friends above mentioned, were anxious that I should write to your journal, as it might help.'

Followed in the same column by 'Spectator' who wondered if:

'... the City Fathers of Yeovil realise that by the vigorous police system of summoning and fining all offending motorists without warning they are driving a lot of trade from the town? Yeovil is, to a large extent, dependent upon external trade, but no motorist is going to shop or eat a meal at the risk of offending unknown by-laws and being fined without warning. I can assure them that my friends and I have decided not to shop in Yeovil for the present or to stay there for a meal or a drink, and that I have today given notice to the shops where I have dealt, telling them why I can no longer continue to do so. The average motorist is a peace-loving citizen, only too ready to take heed of a friendly warning, and to park in proper places, but resents being penalised by fines or car-park charges, when stopping only for a brief while in the town.'

However, gloom of a different kind hung over Yeovil on Monday 19 November 1934 when the *Western Gazette* reported that:

'One of the densest fogs experienced in the Yeovil district for many years enveloped the town and parts of the countryside on Monday. The conditions were by no means general, and it was possible within the borough boundaries to grope carefully along streets to emerge into areas where the air was completely clear. The districts most affected were the main streets and the low lying parts of the borough and district. Where the fog was thickest visibility was restricted to a yard or so. Traffic was slowed down to walking pace, and the earliest days of locomotives were recalled by the spectacle of "warning" men walking in front of vehicles as a guide to drivers. Pedestrians had some amusing and unpleasant experiences as they groped along railings and buildings to maintain some certainty of direction, and collisions were frequent.

'Visibility was poor in the morning, but at mid-day conditions appeared to improve. An hour or so later, however, the fog began to be intensified, and visibility gradually got worse, until in the main streets of the town it was impossible at times to see more than a few feet.

'The patchiness of fog is indicated by the fact that, although in Princes Street in the early evening, it obscured shops and buildings from the sight of pedestrians a few feet away, when the hospital cross roads was reached, there were only traces of the fog, and Hendford Hill and the higher areas were almost clear. A heavy curtain of fog hung over the entrances to Kingston and Higher Kingston and in those streets as far as visibility went, it was as though night had descended.

'Conditions were in all probably at their worst between five and seven p.m. when it was impossible to see even a yard ahead in many districts. There were slight collisions between road vehicles but as they were travelling at dead slow speeds little damage was done. As the evening wore on conditions gradually improved and by midnight there was a fair visibility. Road services were delayed but the train services were not greatly affected. The attendance of the Torquay Municipal Orchestra's concert at the Prince's Theatre was undoubted adversely affected, and one of the organisers was of the opinion that it made about £10 difference to the takings.

'The fog caused the postponement of a concert to be held in the Hamdon Hall, Stoke-under-Ham. The Revd Douglas Ballard had arranged the concert and the Boy Scouts Troop was to have benefited. The "Klinkers" Concert Party commenced the journey from Yeovil in good time to allow for the difficulties of travelling, but soon found the only way of making any progress was by a guide walking in front of the cars. In this way it took half an hour for the cars to get to the end of Preston. Here the fog became thicker, visibility being limited to a few yards, and the person walking in front of the cars could not be seen. Enquiry was made of another motorist who informed the party that conditions were the similar just beyond Montacute, and it was agreed to "phone the Vicar, who agreed to make arrangements for the concert to be held next Monday. Although conditions were so bad near Yeovil at Stoke it was a clear evening."'

MAYOR MAKING

Until 1949, Council Elections were held in November, and Yeovil elected the Mayor at the annual Town Council meeting on 9 November (except when the day was a Sunday and then it would be on the 10th.) The election of the Mayor was always something of an event and I have looked at a few of those Mayor makings of a century ago.

On 9 November 1893, Councillor Sidney Watts was elected Mayor and, at the close of the meeting, the new first citizen invited his fellow councillors, officials and the press representatives to join him in refreshments at which toasts were drunk and speeches delivered. At the close of the proceedings, and led by the Military Band, the councillors and officials conducted the new Mayor to his home in Princes Street. During the afternoon and evening, 'merry peals were rung from the bells of St John's church, and the band paraded the town playing lively selections'.

Councillor Watts was re-elected Mayor for a third term on 9 November 1895 and, on this occasion, the Military Band played outside the Town Hall while the church bells rang out. Preceded by the Mace Bearer, the new Mayor, councillors and officials, accompanied by the Military Band, walked through the streets lined by a large crowd to his home.

Photographs of members of Yeovil Town Council 1897-98 including past and future Mayors Councillors Sidney Watts and John Vincent.

Councillor Sidney Watts' fourth re-election was the occasion of a much grander procession. All the shops and houses in Princes Street were 'gaily decorated' and this year the crowd lining the streets was even bigger. The Mayor, accompanied by Councillors C. W. Pittard and W. Cox, his proposer and seconder, rode in an open carriage 'drawn by a pair of greys, with postilions' through the cheering crowd.

On 9 November 1898, Councillor John Vincent was elected Mayor and served for three terms. The traditional banquet given by the Mayor on his re-election in November 1900 was quite a splendid affair. The *Western Gazette* reported that the upper portion of the Town Hall was 'skilfully converted by means of curtains and tapestry, into a sumptuous dining room. The walls were also most artistically draped, and the table decorations of the most tasteful kind, reflecting greatly on the caterer, Mr W. T. Maynard, who personally superintended the arrangements ...'

The menu was as follows:-

'Hors D'oeuvre
Oysters

Soups
Thick Turtle · Princess Royale

Fish
Turbot · Sauce Mousseline
Devilled Whitebait · Soles a la Colbert

Entrees
Fillets of Beef a la Chateaubriand
Kidneys Saute Au Vin

Removes
Saddle of Mutton · Rolled Turkey and Ox Tongue
Roast Chicken and Sausages

Sorbet

Game
Pheasant · Grouse · Black-Cock

Sweets
St Vincent and Bachelor's Pudding
Pine Apple Jelly · Charlotte Russe
Milan Soufflet

Savouries
Devilled Sardines · Olives Farci

Dessert
Pines · Grapes · Bananas &c
Café Noire · Liqueurs'

After surviving this feast came the toasts – all fifteen of them – The Queen, The Prince and Princess of Wales, and the rest of the Royal Family, The Bishops, Clergy and Ministers of all Denominations, The Imperial Forces, The Mayor, The Deputy Mayor, The Aldermen, The Borough Magistrates, The Town Clerk, The Councillors, The School Board, The Vice-Chairmen, The Town and Trade of Yeovil, The Press, and finally The Ladies. Between the toasts, songs were sung by Messrs G. R. Allen and W. B. Milborne, duets from Messrs W. Cole and F. Clements, and Mr Walter Raymond, the Somerset author, and Mr Shoreland Aplin 'added to the pleasures of the evening by giving a couple of recitations. The singing of the National Anthem brought a most enjoyable evening to a close'.

Councillor W. W. Johnson was elected Mayor on 9 November 1902 and the surroundings for his banquet in the Town Hall were quite splendid. Once again the *Western Gazette* reported that: 'A tent of muslin drapery with Indian tapestry had been temporarily erected. In this snug enclosure, with the canopy of white and yellow art muslin, its alcoves with huge palms on either side, the glittering candelabras and silver stands on which stood a cornucopia of luscious grapes and fruit, the many-coloured fairy lamps casting a soft subdued light over the whole – the place bore a resemblance to those enchanted apartments, imaginary or real, of antiquity.

'Four tables had been arranged, the head table running in a parallel direction along the east end of the hall. On this table stood three silver stands on silver mirror centre pieces, while to the other less pretentious tables were allotted one stand each. The windows were hung with white muslin curtains underlined with red, and at various positions in the room stood large mirrors festooned with plants. The carpet had a border of red felt. Those who saw this banqueting hall declare that they never saw it look prettier. The whole work was carried out by Mr Connock, under the supervision of Mr W. T. Maynard, caterer'.

And what of the menu:

'Hors D'oeuvre
Oysters

Soup
Real Turtle · Ox Tail

Fish
Turbot-Lobster Sauce · Soles-Sause Tartare

Entrees
Creme of Chicken and Mushrooms · Lamb Cutlets and Peas

Sorbet

Game
Grouse · Pheasant · Golden Plover

Sweets
Johnson Pudding · Macedoine Jelly · Strawberry Creme · Charlotte Russe

Savouries
Devilled Prawns · Canape of Olives

Dessert
Café Noire Liqueurs'

The Toast list was impressive with sixteen toasts, one up on Councillor Vincent – Our London Friends was added. There were songs between toasts, a cello solo and Mr A'Court Simmonds' band played selections. They certainly knew how to have a good evening back in those far off days, but before we get too excited about the cost to the ratepayers, I should explain that the entire cost would be met by the new Mayor from his own pocket – you had to have a 'few shillings' to be Mayor in those days.

NOVEMBER 1945

On Friday 2 November 1945, the *Western Gazette* reported that at the previous day's Yeovil Borough Council elections – 'For the first time younger citizens who are not ratepayers swelled the municipal vote.' Half the 17,500 electors voted at these first local elections held since the end of the war and resulted in net gains on the Borough Council of two seats for Labour, one for the Independents and the first seat for the British Legion.

The National Savings Campaign's fund raising 'Thanksgiving Week' began on Saturday afternoon, 3 November, when Yeovil's Member of Parliament, Lt. Col. W. H. Kingsmill DSO, MC, performed the opening ceremony in The Borough and took the salute at the march past of Service units led by the Band of the Duke of Cornwall's Light Infantry. The week's events included a Victory Ball with Bill Kelly and his Dance Orchestra in the Princes Street Assembly Rooms on Wednesday 7 November, followed by a 'Popular Concert' on the 8th given by Norman Brooks and his Broadcasting Sextet, and on Friday the 9th, the Assembly Rooms were the venue for the Yeovil Young Farmers' Club's Fancy Dress Ball with Mons. Paquay's Dance Orchestra.

The Yeovil fashion shop Mayfair presented a Mannequin Parade in the Assembly Rooms on 8 November with 'the Norman Brooks Sextet and a BBC soloist assisting.' A Children's' Fancy Dress Parade organised by Miss Freda Taylor was held in the Park School Hall with 286 entries, and a small boy dressed as 'The Atom' was of the four youngest winners. A large crowd was attracted to the aerial fireworks display organised by Westland Aircraft on Thursday evening at the Mudford Road Playing Fields and £110 worth of Savings Stamps were bought by spectators.

Local businesses and factories entered into the spirit of the week and Westlands held fund raising mock auctions, a Staff versus Works quiz (the Works won by 10½ to 8½ points) and a further quiz at midnight – Day Workers versus the Night Shift resulted in the Night Shift winning by the narrow margin of 2½ to 2. The Westland Players presented two 30 minute excerpts from 'Tilly of Bloomsbury' in the Works Canteen and the Sports Club organised whist drives, dances and a football match. Westlands raised £31,000, exceeding their target by £11,000.

An officer and ten men of the ship's company of HMS *Hesperus*, the destroyer 'adopted' by Yeovil during the war, were guests of honour in the town, and were entertained at dinners and various social events. On display in a marquee on the Fairfield at Huish was a captured German one man submarine (I remember visiting this exhibition), a model of the Shwe Dagon Pagoda at Rangoon could be seen in

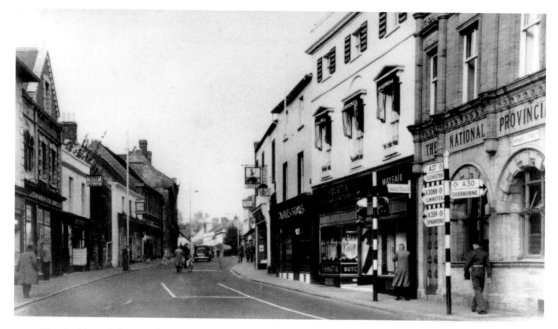

The fashion shop Mayfair is next to the National Provincial Bank by the traffic lights on the black and white pole.

Vincent's Princes Street motor showrooms, and on 2 and 3 November, the Southern National Omnibus Company displayed an illuminated model village in The Borough.

During 'Thanksgiving Week', Yeovil raised £287,864.

At the Town Station on 2 November, The Mayor, Councillor W. S. Vosper, named the fourth of the Southern Railway Company's 'West Country' class engines 'YEOVIL', and drove the locomotive a short distance down the line. Afterwards the Mayor, himself an employee of the Railway Company, entertained to luncheon the Hon. Clive Pearson, Chairman of the Locomotive Board of the Railway, Mr O. V. Bullied, Chief Mechanical Engineer and designer of the engine and officials from Waterloo.

There were several 'firsts' in this first week of November 1945. *Hand in Glove*, the first film about Yeovil made gloves and illustrating all the processes from skins to the purchase of the finished product, was showing in the Central Cinema. The film had been made at Messrs Atherton and Clothier's dressing yards and factory in 1942, but had not gone on public show until this week in November 1945.

Another first was the official opening at Pen Mill Infants School of the first dining hall attached to a Somerset school. The dining hall, measuring 24 ft by 60 ft, could accommodate 120 children, and was painted in 'an attractive colour scheme of dark green and yellow.' The *Western Gazette* reported that: 'Ald. A.H.J. Stroud, chairman of the Education and Canteen Committee, said, "I think you will agree that it is better for the children to have their meals here than in the rather stuffy atmosphere of their classrooms." He said that 75 per cent of the children attending the school had their mid-day meal at the school. It was their duty not only to cultivate the children's minds,

but also their physical health. Unless they were healthy, he said, they could not take full advantage of the educational facilities provided at the school.'

The *Gazette* went on to report that more halls were to be opened at Huish Infants and Junior and Reckleford Junior Schools.

At six o'clock on Tuesday morning 6 November, a queue began gathering outside Moffat's shop in High Street following an announcement that a large allocation of Christmas toys had arrived; the shop opened two and a half hours later at 8.30, and was sold out in just over an hour. Monday 5 November was the first Guy Fawkes Night since 1938 on which bonfires and fireworks could be lit and let off, and the first time we could build our street bonfire on the vacant plot we called the 'Greenie' on the corner of Orchard Street and West Street. I seem to recall that fireworks were in short supply, but we had a good time and the bangers were definitely louder and more powerful than today's. On 4 November there was one of nature's firework displays when several houses in Preston Road were damaged by lightning in a thunderstorm and a house in Home Drive was struck and its chimney cut in two. The following letter to the Editor appeared in the *Western Gazette* on 2 November: 'On Tuesday evening of last week I witnessed the humiliating spectacle of British workmen returning home from work being turned out of a Southern National bus to enable a few German prisoners (whose vehicle had broken down) to continue their journey. The merits of the case are unknown to the writer, but the reactions of the workers concerned can better be imagined than described. The question that immediately presents itself is however – Did we, or did we not win the war? The moral is obvious. An efficient public service with a modicum of consideration for their passengers, would have despatched a relief bus for the prisoners from the depot.'

December

DECEMBER 1889

There was good news for home-makers in the first week of December 1889 when Mr H. White announced in the *Western Gazette* that: 'THE EASIEST AND CHEAPEST PLACE TO FURNISH IS where a stock is kept of all kinds of Furniture, Bedding, Bedsteads and Glasses. H White has great pleasure in announcing to the general public that he has just laid out with complete SUITES of DRAWING-ROOM, DINING-ROOM and BED-ROOM FURNITURE, the largest Hall in the District, known as the Skating Rink, No 10, Hendford, within sight of his High Street, Bedstead and Bedding Warehouse. Inspection respectfully solicited. Established 30 years.'

The *Gazette* reported that the gift of eighteen beach, elm, sycamore and lime trees by Mr J. H. Paynter had now been planted down both sides of the approach road to Pen Mill Station. It was acknowledged that – 'No appreciable difference is made to the appearance of the road at present, but when the trees begin to shoot in the spring they would make the approach to the station more attractive.' Some of the trees are still decorating the approach to Pen Mill Station.

Early December 1889 provided several evening entertainments. On 2 December, the Flower Show Committee of the Working Men's Liberal Association held a Variety Entertainment in the Town Hall and the Corn Exchange. The evening began with Mr W. T. Maynard's children's magic lantern show in the Town Hall which 'consisted of a number of representations of old abbeys and castles of England, some comic slides, and the portraits of a few Liberal leaders.' The show was followed by a concert of vocal and instrumental music. During the intervals Mr Maynard's magic lantern projected views onto a white sheet and, at the end of the concert, Mr Clarence gave a juggling entertainment. A public dance was held in the Corn Exchange to the music of the Yeovil Town Band.

On the first Friday in December, the *Western Gazette* began its third season of popular weekly entertainments in the Victoria Hall in South Street. The Editor, Mr Sylvester, presided over the programme of piano solos, songs, recitations and 'the

Mr H. White's Furnishing Warehouse at The Rink, Hendford, was opposite the Manor Hotel.

illusion and feats of legerdemain by "Professor Macmillan".' The fourth People's Saturday Night entertainment of the winter season was held in the Victoria Hall on the following evening, when an audience of some two hundred townspeople enjoyed music, songs both serious and comic ('If she asked me to go to Jericho' was one of the comic variety), some carols and recitations.

Yeovil Company of the Volunteers attended Divine Service at Barwick Church on Sunday 8 December under the command of Major Marsh. At 10 a.m. the company paraded in the Borough and, led by the Volunteer's Band, marched down Middle Street and along Newton Road to Barwick. At the church gate, they were met by Mr Churchwarden Pavitt, a retired member of the Volunteers, dressed in his colour sergeant's uniform, and 'a hearty service was held.' At the conclusion of the service, the company marched to Barwick House where Mr Lloyd Jones provided wine and biscuits, and duly refreshed the Volunteers marched back to Yeovil via Hendford Hill.

A regular soldier, refreshed by something stronger than a glass of wine, appeared before the Town Magistrates and pleaded guilty to using obscene and abusive language on the premises of the London and South Western Railway Company in contravention of the company's ninth bye-law. The bench was told that: 'At about 3.30pm in the afternoon of 9 November, the defendant, in company with another man, were crossing the footbridge at the joint station, when the former owing to his intoxicated condition, was stopped by Charles Coster, in the Company's employ, who considered he was not

in a fit state to travel by rail. He had a ticket which his friend had procured for him. Mr Maunder, the Station Master, came to Mr Coster's assistance, took away the tickets of the defendant and his friend, and refunded them the money. When the defendant was just outside the exit gate, he, in the presence of a number of passengers, "began piling on Mr Maunder's head such a volley of abuse, as he was glad to say was seldom heard, at any rate on the Company's premises." The next day the defendant was given the opportunity of apologising to Mr Maunder. If he had done so he would have been forgiven. He refused to apologise, and treated the matter with utmost indifference. Mr Frederick Salter bore out Mr Maunder and Mr Coster's statements. The defendant pleaded intoxication in extenuation. – Fined 10 shillings and costs, or seven days.'

The *Western Gazette* reported that a fox was disturbed by a terrier in Mr W. Mayo's garden in Kingston, and a fair old chase ensued. The fox, with the terrier in pursuit, cleared Mr Mayo's garden fence, ran across Ram Park (now Sidney Gardens), and into the garden of Mr Brutton's house (now Park Lodge). The chase continued around the garden and back across Ram Park into the garden of the mayor, Mr H. W. Southcombe, where the fox was caught 'all alive O' – of the fate of the fox, the *Western Gazette* is silent.

The 703rd Starr-Bowkett Building Society held a ballot meeting at 41 Vicarage Street on 2 December, and members drew lots for the periodic allocation of loans for house purchase. Number 137 was drawn and Mr Pennell of 6 Duke of Clarence Yard, Stars Lane, was granted a loan of £100, interest free. However, the next number drawn, number 64, was found to be in arrears with his contributions, and the draw was taken again. The £100 loan was granted to Mr White of Castle Cary.

Finally, the Yeovil Postmen were granted a Sunday off, to be taken in rotation, and the *Western Gazette* wrote that it would be welcomed by them.

CHRISTMAS IN THE SHOPS – 1898

This article appeared in the *Western Gazette* just before Christmas 1898:

'Christmas, the time of fun and frolic, gift giving and receiving, is once more almost upon us, although, with the thermometer standing at over 50 degrees, it requires a rather strong imagination to establish the fact. Meanwhile everyone is hoping for a spell of fine, cold weather, and quietly speculating in his mind upon the likelihoods of seeing his hopes realised. The approach of the festive season is signalised in nearly all the local tradesmen's windows, and extensive preparations have been made to cope with extra influx of business generally attendant upon this season of the year.

'A very attractive display is made at Messrs Clements' shops in High Street, the Borough and in Sherborne Road. The windows of the High Street establishment, in particular look very pretty in their dressing of fancy boxed chocolates, and tins of biscuits on one side, and Yorkshire Hams, cheese, &c. on the other.

'Mr C J Hook, at the Golden Canister, Middle Street, has also a window full of fancy chocolates of all descriptions. Wines and spirits may be here obtained, whilst this establishment has longed been famed for its Christmas fruit.

Mr McMillan's window display in his High Street shop.

'One of the prettiest shows in the Borough is that of Maynard & Son. Their windows are tastefully dressed, one of the chief attractions being a complete model in sugar, of the new Capital and Counties Bank premises being erected at the corner of Princes Street. They have an almost endless variety of chocolates, bon-bons, and the like. Wines, spirits, &c., can also be obtained here.

'On the opposite side of the road. At Mr McMillan's, an elaborate display of ties, silk handkerchiefs, dressing gowns, and leather goods suitable for presents is made, and a large variety of gent.'s hosiery. &c., is to be found a few doors off at Mr Redwood's. – Mr E Wilson is making a special display of ties and handkerchiefs also at his gent.'s outfitting establishment in Middle Street. – The two establishments of Messrs R and E Damon, in the Borough are famed far and wide. They have literally thousands of articles of linen and woollen drapery, mantles and costumes suitable for Christmas presents to suit all tastes and all pockets. They are now making a speciality in fur goods, in which they offer some decided bargains.

'To deal with the butchers is a somewhat difficult task. At Mr J J Brook's shop great preparations have been made. His special purchases include the first and second prize heifers at the Yeovil Show, grazed by Mr W Miles of Bearley, the first prize Devon steer at Bridgwater Show, a pen of prize Devon wether sheep, also grazed by Mr Miles, and other mutton fed by Mr A Hodges of South Petherton. In addition to this he has a choice supply of prime poultry, and game of all descriptions. – Mr Hutchings, Princes

Street, will have a fine display of Christmas joints. He purchased the prize heifer at
Yeovil Show, fed by Mr Hallett of Tintinhull, Devon oxen, fed by Mr Miles, a pen of
grand Down wether sheep, grazed by Mr Wake, of Chilton Cantelo, and he will also
have a fine show of poultry and game. – At Mr Elliott's Middle Street, a good selection
of prime joints will be found, together with poultry of all descriptions. His mutton
includes several Exmoor sheep, grazed by Mr J Brutton, and the housewife in search of
a good Christmas joint will find all she requires at Mr Loney's, Middle Street. – Some
grand beef and beautiful wether mutton will be killed for Christmas by Mr C J Hayne
of the Borough, and his best show of meat on Thursday should be one of the best. He
has also made some extensive purchase of fat poultry for Christmas.

'Amongst the drapers, Mr Eli Wilson, Middle Street is making a speciality of
children's costumes. Messrs Davies and Rendall have a special show of pinafores and
aprons, Mr Richardson of fur boas, necklets and woollen goods, and Mr Edwards
of 2 Hendford is showing a great variety of artificial plants and flowers suitable for
decorative purposes.

'The jewellers are making a big display. Mr Fox of the Borough, has recently
bought the business of Messrs Hancock, Cox & Co., in Middle Street, and here he
is conducting a sale of the stock at very great reductions. Bargains of all kinds can
be found here, whilst Christmas gifts to suit all pockets may be obtained at his other
establishment in the Borough. Here he has a remarkable show of ladies' rings and
brooches – Mr Purchase, 11 Middle Street, is also just in the midst of a Christmas sale,
and a visit to his shop will repay the present hunter. Electro-plated goods, watches,
rings &c., abound.

'Mr Gaylard, Princes Street, has his windows well bedecked with walking sticks,
pipes, and all kinds of toilet requisites, compact little dressing cases and high class
goods. – Mr W B Collins has an extensive collection of Christmas cards, games, and
fancy goods of all descriptions. – Mr J Membury, Middle Street, can supply everything
in the shape of smokers' "tools," and he also has a good collection of useful little
presents of all kinds.

'To those in search of a good strong pair of boots an inspection of Messrs Frisby's
large stock at their establishment in Middle Street, will repay. Here, too, one may
choose from a large stock of ladies' and gent.'s dancing shoes, slippers, &c., at prices
to suit all.

'For a "wee drappie" of good old whisky, Messrs Mann & Co., of the Wine Vaults,
Wine Street, will take some beating.

'A rare stock of sweets and confections for Christmas consumption will be found at
Mr Whittle's, Middle Street. He has chocolates and high class sweets galore, and has
the largest stock of fancy boxes of "pops" in the town. His Devonshire cream toffees
are too well known to need communication.

'For a useful present of cutlery, Messrs J B Petter & Sons, in the Borough, should be
visited. At the same establishment, there are table lamps, brass goods of all kinds, and
almost everything known to the hardware merchant.

'Messrs Price & Son, of Handel House, Princes Street, too, have the largest stock of
pianos, harmoniums, and American organs for miles around.

'Taking the shops as a whole, they have a fascinating look, especially at night, when they are well illuminated, and, from all outward appearances, there will be no lack of good things to make this Christmastide enjoyable.'

CHRISTMAS 1902

Reporting on the Festive Season of a century ago, the *Western Gazette* advised its readers that: 'The season of "peace and goodwill" passed very quietly in Yeovil. The weather on Christmas-day was fine, with a remarkably high temperature for Christmas-day. Late on Christmas-eve and early on Christmas-morning parties of carollers and the Salvation Army Band perambulated the town and played and sang suitable selections to herald the joyful morn. The day itself was even more quiet than an ordinary Sunday. The only attraction on Boxing-day was a football match on the Pen Mill Ground between the Casuals and Devon County, which drew a good number of spectators. Business was suspended from Wednesday evening to Monday morning, and this enabled many of the shop assistants and others to enjoy a good holiday. The traffic at the railway stations was the same as in previous years, a good number of persons taking advantage of excursions both to and away from Yeovil.'

Christmas 1902 was celebrated at the Union Workhouse in Preston Road in 'A manner similar to that of previous years, everything being done by the Master and Mistress (Mr. & Mrs. Wilton) to enable the inmates to spend an enjoyable time.' At 9.15 prompt on Christmas morning, the Revd Preb Phelips conducted a service for the 'inmates' followed by the distribution of oranges, nuts and sweets to the children. Christmas dinner of roast beef, vegetables and plum pudding was served in the dining hall at 12.30, followed by beer and coffee. There were gifts of pipes and tobacco for the men, snuff for the women and more oranges for the children. Three hearty cheers were given for the Poor Law Guardians and the several benefactors who had contributed towards the cost of the meal. Christmas tea was plum cake, bread and butter followed by a 'sing-song' and at the close of proceedings three cheers were given for the Guardians and benefactors – 'the day being one which will long be remembered'.

The wards of the District Hospital at the Five Cross Roads were decorated with holly, evergreens and texts by the Matron and nursing staff. The Christmas tree given by Mr W. E. Phelips was hung and surrounded with gifts received from a large number of local benefactors, and some thirty patients and their guests sat down to Christmas tea in the hall. Later that evening, each adult patient received two gifts from the tree and the children toys and sweets.

One man's holiday is another's work day, and Christmas 1902 was a very busy one for the Post Office staff. The *Western Gazette* reported that: 'The business at the local Post office this Christmas has been far heavier than on any other previous occasion, and the energies of the staff have been taxed to the utmost. Thanks, however to the commodious new premises in Middle-street the work was dealt with expeditiously, and the conditions were much less trying than in previous years. During the Christmas week the system of conveying the mails to and from the railway stations by omnibus

POST OFFICE & MIDDLE ST. YEOVIL.

The Christmas mail of 1902 was dealt with 'expeditiously' in the new Post Office in Middle Street.

had to be supplemented by the use of a horse and van, and the van was always loaded to the utmost. A very large number of Christmas parcels were delivered in the town, and a horse and van had to be used for this purpose, as well as the new hand cart recently provided, and even then deliveries of parcels was made on foot. As regards the rural district, the loads were so heavy that the postmen could not carry them, and horses and carts had to be used in all directions. The number of Christmas cards were unprecedentedly numerous, and the postmen had a trying time. On Christmas-day morning and also on Boxing-day morning it was found necessary to duplicate nearly the whole of the town postmen's walks – so numerous were the letters received for delivery. This extra business naturally caused a great amount of work for the clerical staff. The telegraph work was also exceedingly brisk during the Christmas, and the recent introduction of the post office cycles for the deliveries of telegrams proved a great boon.'

However, for one tramp the 1902 Festive Season found him up before the bench. On 27 December, a tramp named Angel was brought before the Borough Magistrates charged with being drunk and disorderly and assaulting the police on Boxing Day. He pleaded guilty to the first charge, but stated that he could not remember the second. Police Sergeant Hinder told the bench that following a complaint, he had gone to Park Street on Boxing Day and had been told that the prisoner had been thrown out of two public houses. The sergeant had finally found him in Hendford staggering around

in the road and using objectionable language. He had taken the tramp into custody, but at the police station the prisoner had lashed out and hit PC Mitcham in the face, giving him a heavy nose bleed. The Magistrates sentenced Angel to fourteen days' hard labour for the first offence and one month for the assault, both sentences to run consecutively.

The *Western Gazette* reported that: 'The prisoner at first took the punishment as a mild surprise, and muttered something to the effect that he hoped they (the Bench) would have a happy New year. This mood, however, quickly changed to one of "impudent audacity" for in a loud voice he started "singing" and shouting what he called hymns. He was promptly hauled back by the police and Alderman Cox told him that his conduct was most improper, and that he had no right to sing in Court. The prisoner replied that there was no harm in singing a hymn. The Bench increased the penalty for drunkenness to 21 days, and the prisoner again shouted and sang in a loud voice as he was being removed.'

PARTIES AND PLAYS

I always enjoyed the autumn term at school. There were more things to look forward to than at other times of the year – collecting and playing conkers, fireworks and Bonfire Night, the autumn colours and frosty mornings, cooking sweet chestnuts etc., and, of course, Christmas, and would it be a white one with snow!

The week before Christmas was the best, putting up the Christmas tree, trimming the house, collecting holly, going into town on Christmas Eve to see the shops all trimmed and lit up, carol services, parties, Nativity Plays, the last day at school when there were no classes and we went home early, and finally the expectation of Christmas morning and what it would bring.

Nearly sixty years ago, as the town emerged from the dark years of war, Yeovilians were going to enjoy Christmas 1948.

Doubtless the Westland Apprentices had a good time at their annual party on 22 December and so did the fifty staff of the Westland Drawing Office at the Mildmay Arms Hotel at Queen Camel on the following day. Entertainment was provided by D. Woolcott on the piano, J. Rivett played the violin and N. Banfield performed on the one-string fiddle. There was comedy from P. Stuckey and E. Greenwood and carols were sung by L. Wells and the Drawing Office Choir.

The Vita Ray Laundry Social Club entertained over ninety children of employees to a Christmas party in St Michael's Hall and each child received a bag of sweets and an orange from the tree. In the evening, 140 employees and friends listened to a concert followed by dancing and party games.

The *Western Gazette* reported that: 'Provisions for the tea enjoyed by the 128 children of the Hendford Infants School on Monday were baked, as in the previous year, by a father of one of the children who is a confectioner. Individual bags of party food were subsequently sent to children unable to be present ... Mothers who came to fetch their children were invited to a short carol service the next day. The youngest

Classes 7, 8 and 9 of Huish Junior School, shown here in 1986, entertained the school on 16 December 1948, and the parents on the 21st.

children lit candles on an electrically lit Christmas tree. The six-year-olds contributed a playlet "The Hours of the Clock" and parents joined in singing favourite carols.'

The Grass Royal and Summerleaze Park Nursery Schools held their parties on the same day. At Grass Royal, Mr A. Lamb, one of the school managers, distributed presents to the children who sang carols and recited nursery rhymes. The Summerleaze children sang, danced and played their percussion band in front of the Christmas tree from which presents were distributed.

On Friday 17 December, the Women's Joint Committee of the Yeovil Conservative and Unionist Association held a Christmas party in the Princes Ballroom with dancing to Bill Kelly and his Orchestra. A demonstration of modern ballroom dancing was given by Mr and Mrs Reg Allen and old-time dancing by Mr and Mrs P. Bike, Mr and Mrs D. Harvey, Miss Kerswell, Mr E. Giles, Mr F. R. Murrell and Mrs S. Phillips, members of the Yeovil Gay Nineties Club. The entertainment was in the hands of Mr Everett Kay, conjurer, who also performed the following week at a party given by the Yeovil Red Cross to the old people who attended their Foot Clinic.

The *Western Gazette* reported that about '150 Art and Craft School students held an enjoyable gathering in the Art School of the Art and Technical Institute, Kingston, on Friday. The entertainment consisting of games, music and dancing was directed by Mr. C. Hutton and music was provided by Mr. C. Fyson. Special features were the gay decorations and a charade, both carried out by the full-time art students, and some community carol singing.'

The children of the South Street Baptist Sunday Schools presented a Nativity Play called 'The Stained Glass Window,' to a large audience in the Newnam Memorial Hall. The piano accompaniment was played by Mr Bert Gillett and the *Western Gazette* listed the following cast: 'Margaret Cheetham, Pat Riggs, Richard Best, Barbara Windsor, Ann Payne, Heather Thomas, Barbara Thomas, Nigel Richards, Norman Reading, Alwyn Powell, Harold Quarrell, Brian Frosdick, Margaret Rogers, Graham Powell, George Spinner, Bleakley Burrough, Marion Riggs, Richard Best, Gladys Powell, Maureen Fisher, Jean Reading, Pearl Gillard, Janet Beare, Mary Trevett, Pat Baker, Esme Sims, Jill January, Kenneth Leaman, Graham Riggs, Betty Beare, Dorothy Burt, Joan Millard, Joyce Douse, James Millard, Brian Little and Eileen Gillett.'

During the morning of 16 December, the children of classes 7, 8, and 9 of Huish Junior School entertained the school with a Nativity Play; in the afternoon they performed before the Infants School and on the 21st their parents enjoyed the play. The young performers were: Patsy Chant, Kathleen Cleave, Glenys Gould, Molly Hallett, Jacqueline Matthews, Janet Mountain, Annette Rogers, Stephanie Sibbick, Valerie Stidson, John Collihole, Colin Dawson, Colin Kettle, Earl Pennell, Pat Stone, Sonia Keltarowsky, Judith Hiscott, Pat Allen, Angela Davies, Gillian Davis, Hazel Langdon, June Norton, Richard Neal, Stanley Hazell, and Gerald Reeves – Derek Randall, Royston Stanley, Alan Bartlett, and David Lloydlangston helped behind the scenes.

At Yeovil School, the Houses held their Christmas Socials as recounted in the School Magazine: 'IVEL ... Evidence of the ability of house members in certain directions was provided at the House Christmas Social and once again we have to thank all those boys (and their parents) who brought food which was readily consumed.

'SCHOOL ... End of term was celebrated by a most enjoyable Xmas social consisting of the popular three part programme – eating, playing and being entertained.'

However, for Kingston House the writer was a little critical of certain aspects of the event: 'KINGSTON ... Once more the House held a successful Christmas Social. The primary requisite of a schoolboy's life was amply provided for by gifts from generous parents, by purchases and by the efforts of the Kitchen staff. The Stage Entertainment, though good, suffered slightly from under-rehearsing, and from a very poor response from anyone below the VIth form. It is a most unappreciative, even lazy, attitude which allows those who have the greatest calls upon their time, to shoulder the burdens which should be shared by all. However, to those who did help, both on the stage and in the kitchen, may we say a very grateful "thank you."'

The employees of the seven associated factories of the glove manufacturers Messrs R. & J. Pulman invited the company's directors to a party at the Liberal Hall where over 400 people danced and were entertained by the Happy Family Concert Party from Weymouth. Yeovilians tuning into the BBC Home Service carol service on the morning of Christmas Eve would have heard young Roger Martin Stone, son of Mr and Mrs C. Stone of 'Linden Lea,' Sandhurst Road, singing carols with the All Saints Choir School of Margaret Street, London.

New Year 1950

At one minute past midnight half a century ago the forties, those ten years of conflict and unrest, were confined to history and welcomed in were the fifties and the hope for a better future. The *Western Gazette* described those New Year's celebrations, as 1949 welcomed 1950, as 'Scenes reminiscent of pre-war days, including singing and dancing in the Borough a few minutes before midnight, were provided by Yeovilians celebrating the advent of the New Year.'

Led by musicians, revellers from the Liberal Hall and Assembly Rooms converged on the Borough in immense 'Conga' lines and, as midnight sounded, more than 200 people joined in singing 'Auld Lang Syne.' Afterwards, the bells of the parish church sounded their tradition welcome to the accompaniment of strident whistles from locomotives at the railway stations.

The celebrations were in contrast to those of the previous year, when the centre of the town was almost deserted. Thousands of others, preferring the comfort of their own fireside, greeted the New Year at home.

Watch night services attracted good congregations at local churches, and that at the Salvation Army Temple was attended by Mrs Eliza Smith, of 14 Mary Street, now in her 103rd year. Mrs Smith travelled to and from the Temple by car. Previously, at a party at her home, Mrs Smith recited five verses of a hymn that she learnt at least ninety years ago.

The Mayor of Yeovil (Ald. B. Dening), accompanied by the Town Clerk (Mr T. S. Jewels), Aldermen, Councillors and Corporation Officials, attended the parish church on Sunday for the first service in the New Year. Assembling in King George Street, the procession, which included detachments of the police, fire service and ambulance units, marched to the church headed by the Municipal Band. Afterwards the Mayor and officials marched back to the Council Chamber where Ald. S. H. Vincent thanked the Mayor for inviting the Council to attend, and the Vicar for arranging the service.

The Vicarage Street Methodist Church Social was organised jointly by the Methodist Youth Club and the Church Choir. On Sunday morning there was the annual covenant service dating back to the time of John Wesley, which has been held every year since its institution.

Pen Mill Methodists gathered in the schoolroom for their annual social and watch night service. A programme of games was arranged by Messrs D. S. Durrant and P. F. Williams, and refreshments, provided by friends of the church, were served by the Ladies' Working Circle.

Many parents and friends of the thirty-two members of the St Andrew's Church Choir gathered in St Andrew's schoolrooms on Friday for the choir's annual social. The social was organised by Mr Harold Rendell (organist) who also acted as MC.

Nearly 200 members of the Golf Club and their friends attended the annual ball at the Manor Hotel on Friday. The event was organised by a committee of five club officials, headed by Mr John Bradford, with Mr Lance Luffman as secretary, and among those present were three radio favourites well known to listeners to the West Country family programme 'At the Luscombes'. They were Messrs John Bradford (who plays Ted), Lewis Gedge ('Dad' Luscombe) and Michael Watson (Sid). Michael Watson also led the dance orchestra. ('At the Luscombes' was compulsory Saturday evening listening in the Sweet household and what a fine programme it was.)

The town's primary schools returned for the new 1950 spring term on 5 January, but some children in the Westfield and Larkill areas enjoyed an extended Christmas holiday. These lucky youngsters not only had a longer holiday, but they were also going back to a brand new school. The *Western Gazette* reported that: 'When the children file into their new classrooms at Westfield County Infants School – the first of four post-war schools for Yeovil – on Wednesday, workmen will still be hard at work constructing the remainder of the building. The school's four classrooms and two large general purpose rooms, together with cloakroom and sanitary accommodation, were given building priority in order to relieve the heavy pressure on existing accommodation in the town particularly at Huish County Infants School. The second phase of the project – construction of the assembly hall, kitchen, head teacher's, staff and medical inspection rooms – is now in progress. It is expected that the school, which is capable of accommodating 200 children between five and seven years, will be finally completed in the spring. "Besides relieving the overcrowding at Huish, this new school will make possible the closure of two 'outposts' at St. Francis Hall, Larkhill Road and the Westfield Baptist Church Hall which have been utilised as temporary classrooms for some time past," Mr. A. R. McMillan (divisional education officer) told a reporter.'

The *Western Gazette* went on to describe the new school as 'Set in spacious grounds, which will be grass sown and laid out in gardens, it is the first post war constructed in the area of the South East Somerset (Yeovil) Divisional Executive, under the County Education Committee's urgent operational programme. The Headmistress of the new school is Miss E. O. Rogers, who pending its completion, was appointed to a similar post at Huish Infants' School. She will be assisted by Mrs. E. Miles, Mrs. U. G. E. Carey, Mrs. M. A. O. Howles and Miss M. A. Ingham, all former members of the staff of Huish Infants' School.

'The County authority has accepted tenders for the erection of three further schools in the borough, namely Westfield Junior School, Milford Infants' School and Milford Junior School. Work on all three is expected to start almost immediately.'

I wonder what Yeovilians of 2050 will think when they look back fifty years to the Millennium Celebrations? Happy 2000.

End Piece

A festive view of the old thatched cottage at Nine Springs taken on a snowy winter's day over a century ago.